OF ALL THAT ENDS

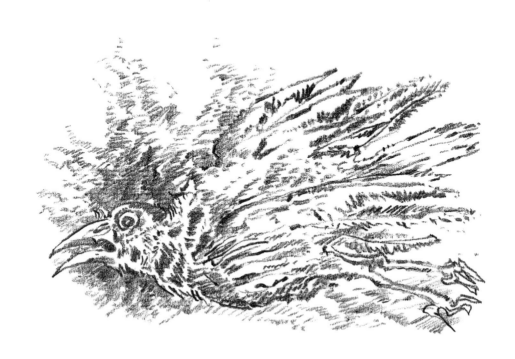

GÜNTER GRASS
OF ALL THAT ENDS

Translated from the German by Breon Mitchell

Harvill *Secker*

LONDON

1 3 5 7 9 10 8 6 4 2

Harvill Secker, an imprint of Vintage,
20 Vauxhall Bridge Road,
London SW1V 2SA

Harvill Secker is part of the Penguin Random House group of companies
whose addresses can be found at global.penguinrandomhouse.com.

Text copyright © Steidl Verlag, Goettingen, Germany 2015
Graphics copyright © Steidl Verlag and Günter & Ute Grass-Stiftung 2015
English translation copyright © Breon Mitchell 2016

First published by Harvill Secker in 2016
First published with the title *Vonne Endlichkait* in Germany by Steidl Verlag in 2015

A CIP catalogue record for this book is available from the British Library

penguin.co.uk/vintage

ISBN 9781910701812 (hardback)
ISBN 9781910701829 (trade paperback)

Original book design by Günter Grass, Sarah Winter, Gerhard Steidl

Printed and bound in Great Britain by Clays Ltd, St Ives PLC

Penguin Random House is committed to a sustainable future
for our business, our readers and our planet. This book is made
from Forest Stewardship Council® certified paper.

For Sarah Winter

CONTENTS

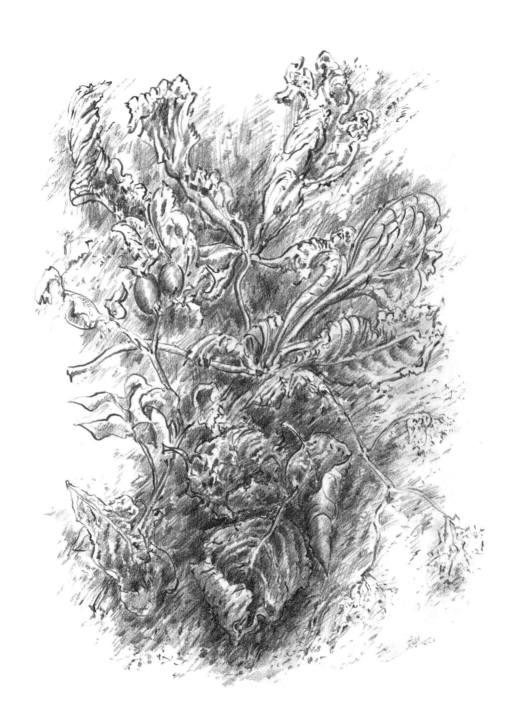

FREE AS A BIRD

When the pipe smoker's heart, lung, and kidneys sent him to the workshop for yet another stay, hooked him up to an intravenous drip, a wretched fellow, and forced him to swallow a growing pile of pills—round, oblong, brightly colored—all whispering warnings on their side effects; when grumpy old age kept asking peevishly "How much longer?" and "What's the point?" and neither lines of ink nor strings of words flowed from his hand; when the world with its wars and collateral damage slipped away, and he sought only sleep, a sleep torn to rags, and estranged from himself he began to lick his wounds in self-pity; when the last fountain had run dry, I was revived, as if mouth-to-mouth resuscitation were still in use, by the moist kiss of a part-time muse on call, and images and words came crowding in; paper, pencil, brush lay close at hand, autumnal Nature made its frail offering, watercolors began to flow; I delighted in scribbling and, fearing a relapse, began eagerly to live again.

To feel myself. Light as a feather free as a bird, though long since fit to be shot down. Unleash the dog with no sense of shame. Become this or that. Awaken the dead. Wear my pal Baldanders' rags for a change. Lose my way on a single-minded quest. Seek refuge among ink-lined shadows. Say: Now!

It seemed as if I could change skins, grasp the thread, cut the knot, as if this rediscovered happiness had a name I could say again.

ON EACH NEW LEAF

With red chalk, lead, graphite,
with goose quill and ink pen,
with sharp pencils, full brush,
and charcoal from Siberia's woods,
with watercolors damp on damp,
then back to black and white—
to scales of layered grays,
bring forth the shadows' silver gleam;
and since from death-like sleep
the muse's kiss first startled me,
forcing me stark-bare naked
into brightness,
I've looked on each new leaf in turn,
obsessed by yellow,
mustard-dazed,
enflamed by red,
faded by fall,
hoping green would wake again,
seeking the way out, wafting gently,
like a feather falling from the blue.

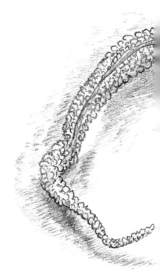

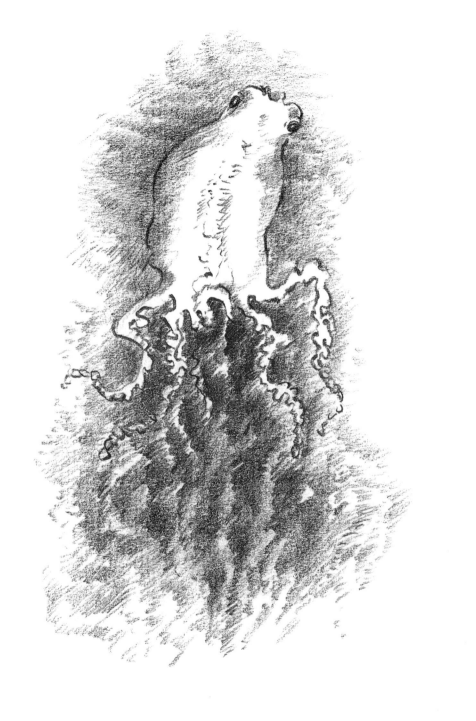

SEPIA AU NATUREL

Again and again the dream where I milk a midsize squid. It's easy underwater, like making love to a daring mermaid strayed from her flock.

You swim up from behind, quite innocently, stay patient, and when the moment is right, attach the pump to the muscular opening of the gland and activate it by pressing a small button. Soon, half forced, half willingly, the squid expels what's normally released as a dark cloud to befog a nearby enemy.

That happened a lot at first, when I was in too great a hurry to harvest the inky brew. Time would go by and still nothing. I would run out of breath. Surface, then try again. Milking squids, like pleasuring mermaids, takes practice.

Since then black milk stands stored in canning jars, a borrowed metaphor. A soupy extract used for pen and brittle brush drawings alike. Washed they reveal streaks of a slimy substance.

The drawings retain the smell long after, at first fresh, then increasingly pungent; especially on days of high humidity, the squid-ink ink recalls its origin.

IN AN ENDLESS LINE

that rises from the bottom left,
then forms steps, hesitates,
ventures back, tumbles downhill,
catches itself, staggers but remains intact,
curves now into an arch, spins in place,
marking time, sets off again,
starts to head outside,
almost losing its way,
sets off yet again,
still sharp enough to find its way out,
surveying in its course the hilly landscape
of a face — female —
colonizes it with vegetation,
leaves blank a few bare islands,
doubles back on itself, evasive, creeps
beyond hearing into the shell of an ear
and nests there; a line
that has no goal,
its only meaning its own breath,
a breath that never tires,
so long as ink keeps flowing.

SWOON

Swoon, an old-fashioned word: in ages past, when tiny flasks of smelling-salts were held beneath the noses of powdered ladies to revive them, swooning was socially acceptable. It offered a ready excuse for failing to take action against some power or other. But now it has ruffled up its feathers to cover us all.

While bankrupts are sheltered by emergency loans or hope to hibernate through winter in failing banks, and the entire world argues that things will turn around, perhaps even head upward, if not now then soon, and while the responsible parties postpone action from congress to congress as if time were no object, the rest of us are willing to be linked totally and forever by the Internet.

Available around the clock. Never beyond reach. Trapped by a mouse click. Data registered back to our baby powder. Nothing omitted. Daily visits to the thrift store, to the movies, to the toilet —immortalized. The long, drawn-out course of our love life stored on a chip the size of a fingernail. Nowhere to hide. Always in sight. Watched over in our sleep. Never again alone.

What to do? In a powerless swoon I abstain, reject what's on offer. No cell phone among my glasses, tobacco, and pipe. No pointers allowed on how to surf, to Google, to Twitter. No Face-book counts my friends and enemies. When no one is looking I use a goose quill. Murmured soliloquies at most, on cow pats, Cartesian devils, and the ants' notion of progress; and yet a power has seized me by the collar too, a power that goes under various names, but remains nameless.

No signal gives advance warning. It feeds on overqualified stupidity. What once was an omnipresence with religious trimmings now presents itself as soberly rational and proof of a civil society.

No! It renders all things transparent, dispenses with memory. Removes responsiblity. Erases doubt. Simulates freedom. Declared incompetent, we find ourselves flopping in the net.

EVENING PRAYER

As a child,
what scared me stiff when I was stiff
was the motto "God sees everything,"
in Sütterlin script on every wall.
But now that God is dead
an unmanned drone circles high overhead
keeping an eye on me,
a lidless eye that never sleeps
And notes all things, unable to forget.

And so I turn childish,
stammer scraps of prayers,
beg for mercy and forgiveness
as my lips once begged at bedtime
for remission after every act of sin.
In confessionals I hear myself whisper:
Ah, dear drone,
make me pious, that I may come
into your heavenly home.

ABUNDANCE

How simple must we become to see in all its diversity what autumn now sheds, first fruit, then foliage. Piles of leaves. A single leaf. Drying it twists and turns, spreads, rolls its edges, stiffens in ecstasy. Each brittle fissure, each panicle, clearly traced. Sharp edges cast soft shadows. Forgetful green blushes into red, merges with rotting apples, pears, worm-eaten plums. And leaves keep falling, though there is no wind.

They fall dizzily, not knowing where they're headed, hesitate, find their way to their own kind, or stray to others, till tree and bush, stripped bare alike, await the first frost. Now only still lifes remain. I bend over, learn to read. No leaf without its inscription. Eichendorff left a poem on chestnut leaves, one I could recite as a schoolboy. And heart-shaped leaves bear traces of Trakl, leading letter by letter to solemn gardens where he, the stranger, saw Sebastian in a dream.

Mysteries are cheap these days. No more embarrassing questions. When the maple disrobed, love started stammering. There's a clearance sale on metaphors. Openings of novels, final lines, a manifesto cries out in vain. Prayers of a babbling child. Summary conclusions. Broken off in midsentence. Letters that remain unfinished. Curses and canticles of hate. Long-sought rhymes stamped in birch leaves. A plot scurries off: a pile of fallen poplar leaves leads to a crime story whose ending is still unclear. And over all wafts the decaying breath of fall.

SNAIL MAIL

Write long letters to dead friends,
and short plaintive ones to a love
who slipped from life too soon.
Plain letters, in simple script,
vague at times, perhaps,
but intense, to the point,
penetrating time itself,
as if no time has passed.

And report too on the dwindling Now,
on the rush and weariness,
a word-drunk eyewitness account,
on the stockmarket, the general falling sickness,
on what's become, what will become, of the children,
and how many grandchildren I've been given,
on what new words are now in fashion,
and which old veterans are now long gone.

Ah, how I miss them, my departed friends,
and my love, whose name
I've kept fresh in a secret drawer,
repeating it endlessly
till the morning wind
blankets my doorstep with autumn leaves
covered in writing, many-colored.

And I see snails
laboring along the postal route,
they come from far away,
on the road for years;
and I see myself each evening,
patiently deciphering their slimy trail,
reading what my dear dead friend,
what my beloved, wrote.

MY OWN SOUNDS

What am I talking about? With whom? Who says do or don't?
Footsteps from one standing desk to another. Things begin but
don't want to end. What's ended only seems so. Threadbare
words. Try keeping quiet.

Who's that coughing, spitting out the lungs' debris? At times an
angel drifts through the slightly-open door, whispering politely,
kindly, trying to palm off assurances on me. About everything
and nothing.

Now quiet is decreed—by whom? Only my own sounds
linger. Something hard falls from the table, the scissors this time.
Yesterday it was my eraser, bouncing three times after it hit. And
tomorrow?

A slim book, wedged firmly between broad-backed volumes,
lures me with poems of rustling autumn leaves. And before that a
visitor came, but left no trace. That tickling on my left ear is one
of the last flies at the window. Or am I the one who can't keep
still?

Again and again re-counting what got lost along the way. Pinning plans to the wall, noting losses, adding profits, staining ink-addicted paper, wadding it up. My breath rasps as I reheat some old battle, but can't recall what it was about.

Now a throat is cleared, announcing a presence. Then someone approaches, but doesn't appear. Now I hum a pop tune where "raindrops" rhymes with "train stops." Then that whistling sound from my willful hearing aid. Now there's something in the attic. That's not me. It's the marten who lives up there.

SOLILOQUY

Alone with words,
chewed till they dissolve,
I listen to him, he listens to me.
He, that's me, dissuades, suggests,
lies, cries and laughs.

He's moody, but feigns cheerfulness
so infectiously that we both
break out in merriment
that needs no other spur
than a grain of salt.

He's silent. I'm talking at him.
We have in common our dead friends
and our many all-too-lively foes:
I count these,
and he counts those.

Now we list all the women
who once, or often, over many moons,
in bed, on carpets, standing up,
we meant to love: true to a word
that was quickly hushed.

Now we argue, go at each other,
till he's no longer sure and strikes
first three then five from his list.
And then we are sad,
as so often afterward.

Now he wants to be me, and I him,
friends who mean to hate no more.
We swear an oath we've sworn before,
to tell each other stories till the very end,
and jokes if needed.

Regarding our death
we agree:
But what happens
out in the unfurnished void
remains an evergreen question.

WITH STAYING POWER

Rereading books that were my lifelong companions: time, that voracious shredder, has not subdued the flood of words, the biting scorn of François Rabelais. And so I never had my fill of him, not when I was young in Paris, where Paul Celan, in a passing remark, recommended the Regis translation; nor in midlife when, with the swelling flesh of *The Flounder* in my suitcase, I sought refuge as I moved from one bed and desk to another; nor now, restless in sedentary rural peace, where I still can't get enough of a work that always seems new, hot off the press, its pots and pans constantly full, authored by a man who was plagued by the censor, who feared the Inquisition all his life, yet never ceased to be a thorn in their side, on his way with or without baggage, with me right behind him.

For the pressures and fears that once forced Rabelais to flee his native land remain unchanged, though disguised by the Zeitgeist. All that's changed are the instruments and methods of torture, in spite of which writing still satisfies an itch.

But anyone who pulls the thread "To be continued" from the spool better have some staying power and an arrogant certainty: the book will outlive you all, all you cartoon hangmen and thumbscrewers, you well-mannered hypocrites and hired choristers, you cowards yapping from the back of the pack, you overly clever, educated illiterates and telegenic executioners; you will never—and you know it—have the last word.

I LACK THE STRENGTH

to split the rough block with a rough wedge,
as Doctor Rabelais did
back in fifteen fifty
in his speech — opening
the fourth book of Pantagruel —
where he brazenly mocked
the eternal return of the moralists,
and to all the popes of his time,
to all those who wore the habit,
read the Mass backward and
pissed in the soup of pious thought.

I'd like to do that today
and throw the media's chorus off-key,
but — ah! — there are too many,
tangled in a web of lies,
so that in the end — like the Curate of Medon —
the tongue falls lame, mockery sours,
salt is wasted, and rage evaporates
before the spark is struck
to set the fuse alight.
I can't even manage a fart
to vex the nosy
snoops of my time,
although I've eaten, as instructed,
flatulent beans by the bowlful.

And so I lay aside the book
that entertained me nights on end,
give thanks to Gargantua and his son,
and their blasphemous, silver-tongued cronies,
with a belch. Yes, I've had enough;
I lack the strength to split
the rough block with a rough wedge.

ON THE INNER LIFE

When, some fifty years ago, I first composed a work in still-hesitant prose, and then, with the certainty of a prophet, a multistanza poem on the egg-*an-sich,* both manuscripts bore the title *In the Egg.* After all, I was convinced that the human race lives in the interior of that immutable Ur-form, interminably scribbling, on what is therefore the inner surface of the egg, our various speculations on the question "Who's sitting on us?," in light of which, at the end of the poem, I maintained that one sunny-to-partly-cloudy day, the power holding sway outside our shell, which goes by various names, would literally chuck us into the pan and sprinkle us with salt.

But since in recent years we've managed to find one or two clever ways of our own to break the shell, all sorts of weeds of doubt have sprung up in my little garden: no wanton supernatural act—or even divinely inspired appetite—is needed to turn us into scrambled eggs.

Even if we were smart enough to streamline egg production someday by breeding cubic chickens to lay cubic eggs, we would soon tire of them, however much they increased sales, and destroy what might otherwise have offered us a little security in the form of thin-walled cubes.

WHICH CAME FIRST

On Fridays the child was served
poached eggs in mustard sauce.
On festive occasions the grownups slurped
eggnog with long tongues.
Before the wars
cookbooks told us:
Take a dozen eggs,
break them, and stir, stir, stir . . .

Nowadays free-range hens
grant me a single
hard-boiled egg for breakfast,
which — blessed with a seal of approval —
has its price.
Yet in moderation
soft-boiled ones taste good too,
spoon after spoon.

We watch our health these days,
busy ourselves with weight-loss programs
to reduce our fatty affluence.
Peace reigns at home, since our weapons
work well enough abroad.
Only occasionally does the question arise:
Which came first,
the chicken or the egg?

FAREWELL TO WHAT TEETH REMAIN

My upper jaw was depopulated some years ago. And only a meager few held the denture in place in the lower. But I could live with it, since adhesive powder helped with the upper. No click has ever revealed my dental condition.

But recently, when two of the four stalwart teeth in my lower jaw, and then the last but one, broke off at the root without protest from the nerve, and only one remained, gleaming innocently thanks to its cap of precious metal, it seemed time, in light of the dilapidation that could be read in the mirror, to review the past and take another look at those milk teeth my mother kept in a small silk purse, no doubt till the end of the war, for afterward the purse was not numbered among the refugee's baggage.

Ah, how they gleamed in pearly innocence. And when their time had passed, and they had all wandered forth, I all-too-quickly believed, with the new ones barely coming through, that I had grown up.

There were, as required, thirty-two of them. An impressive number, though the protruding lower jaw that appeared with puberty—"prognathism" is the scientific term—served advance notice of a premature reduction of stock.

And now there's only one left, still single, who wants to show how stalwart he is. Like his three companions who broke away from their decayed roots, he boasts a golden coat and stands strikingly alone the moment, with a practiced motion, I place my dentures in a full glass of water and refresh them with a fizzy tablet of cleanser.

Onetooth, Lasttooth, fit only to scare the youngest of my grandchildren when I mime hellish laughter with an open mouth, or mumble stories in which my sole remaining tooth—like Hans Christian Andersen's brave one-legged tin soldier—strides through one heroic adventure after another.

THE LAST ONE

As soon as he loses his grip, brea
all as a precautionary measure, I
and place him in a bottle along
him in my Baltic puddle as sea
current, he may make his way th
North Sea, and finally into the A
Cape and reach the Pacific Ocea
of a picture-book island. There
young woman of my damp and
the bottle; the letter she will thro

He would also make a suitabl
a pearl on a pendant, and — acc
placed among the bronzed fish
mired for his luster.

Or instead, once my dentist h
authenticity, he might fetch a sn
needy bank directors, if my nam

I can't think of any other use
me, he could hardly serve as a re
could take him with me to the g

No, I should give him away. I
grandchild should come first? O
till a magpie . . .

He's still holding on, standing
a thread. Can't crack a nut. At n
symbol of transience. Which is
place my dentures aside, open n
in a self-portrait.

I'm still not certain. Should I
ink or soft pencil shades? My la

OVER THE ABYSS

When, with wobbly feet
and a chronically unsteady disposition,
I sought support, only to find
that a complex sentence I had believed
eternally fixed and firm
had crumbled between my false teeth,
I clutched instead that branch
which, since Dürer's copperplate days,
has thrust its gnarled way into the picture,
rooted at the edge of an abyss
over which I now dangle,
swaying comically,
a toothless fool.

SELF-PORTRAIT

Old codger, chewer of gums,
fit for nothing but spooned pap
were it not for his false teeth
and their nightly glass of clean water.

Spit, spit it out, spit it out!
till not a drop is left.
Get rid of the phlegm
so diligently collected.

Walks at ebb tide
step by step,
till high tide wipes away
all recognizable trace of him.

Now — long since short of breath —
with his one last tooth,
he will never again say Yes and Yes.
Just No, no no and No.

This well-known little song
has only a few verses.
Whenever it's sung the desert becomes
an echo-free rehearsal room.

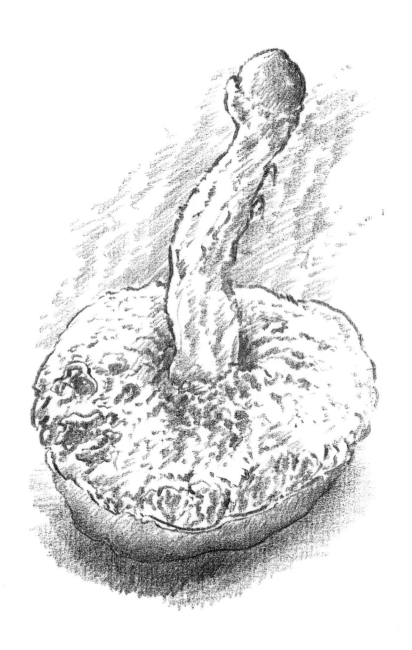

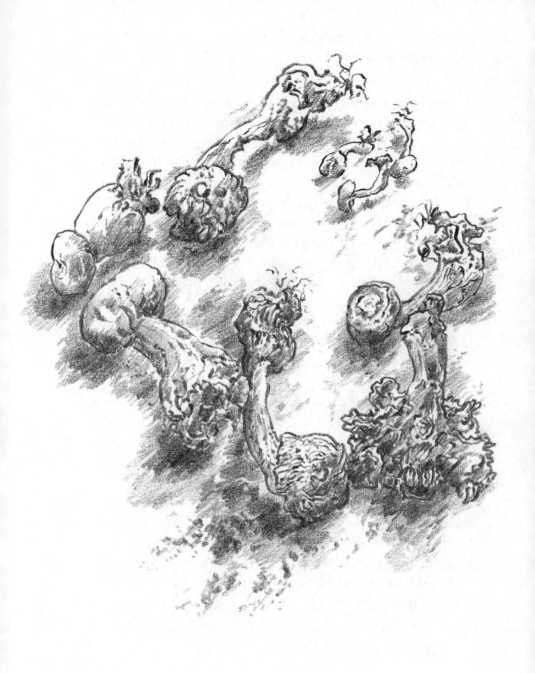

STANDING SINGLY AND
IN FAIRY RINGS

They're often sought in vain, but when the sun warms the ground again after rainy days, they shoot up through the moss, lift the leaves, and colonize the heath among the junipers, standing singly or in fairy rings: Goat's Lip, Parasol, families of Puffballs, Moss Heads fresh with dew, Red Caps near alders and birches, Bloody Milk Caps beneath the pines, the tasty Trumpet of Death.

When Napoleon ruled, I strolled among the mushrooms with Sophie for chapters on end, later with you and with you. Each minding his or her own basket. And we were always warning each other: Not that one, not that one either, that's Seidenriss, it's poisonous!

We knew places now built up, paved over with concrete, snack bars, flagstone paths. And yet, half-shaded spots still remain at the forest's edge and under oak trees hinting of Steinpilz, king of the mushrooms.

We often went by smell, which can be deceptive. I saw more in a mushroom than it stood for. After Chernobyl we paused, held back for an autumn or two, discussed contaminated forest floors and half-lives over coffee and cakes. But then fear abated, gentle October days lured.

All of them — even Slippery Jacks, in spite of their slimy surface — are irresistible: the moment they're wiped clean and free of mites, cut into slices, their aroma recalls fleshly love. In an iron skillet they turn moist, and stirred with a little cream and then sprinkled with parsley, they appeal even to friends who normally wouldn't trust a mushroom an inch.

COMPLAINTS OF A TRAVELER
GROWN SEDENTARY

Giving up Alpine vistas
was always easy.

Nepal never tempted me. Neuschwanstein
is awful.

I walked the beach alone and with children,
stooping, step by step.

Ah, my Portugal lost, how I miss
your southwest coast.

Never again to gaze toward Morocco, the desert,
weary of Europe, smoking my pipe.

Traveling only by finger on maps,
no passport or baggage.

Autumnal pang, because deep in the alder thicket
Red Caps are standing on white legs.

It's hard to let go. Some things are easier,
others give rise to howls of complaint.

INNARDS

When cows' stomachs still hung in rags on hooks at the butcher's like freshly washed terrycloth hand towels, and chopped tripe for a large pot was sold ready to go, I shocked my mob of children when, as family chef, I set this tasty dish, with white beans or in tomato sauce, on the table.

Even today they moan "Uuuugh!" when I praise pig's kidneys in mustard sauce or breaded brains with cauliflower and mashed potatoes. They shiver with disgust when they're reminded of beef liver, sweetbreads, or calf lung hash. They are appalled by chicken gizzards in lightly spiced broth and beef bone marrow on black bread with salt. "Sickening!" they say with a shudder.

What once enlivened the palate is now forbidden. No slaughtered animal dare be recognized; a pig's head serves only to jell an aspic. Whatever used to grunt, moo, cackle, neigh, is turned into sausage. And when I was going on recently about a dinner I once shared with friends long dead, a meal devoted to the rich inner life of animals, celebrating fine taste by its aftertaste, and rewarming old stories in which grilled cod liver appetizers, followed by goose giblets stewed with sweet raisins and thickened with goose blood, were served as invitation to a wedding, the cook in me was unmasked as a boogeyman, and I was, if only metaphorically, pilloried as a father.

ONCE

there stewed over a low flame
within a covered pot
for a good two and a half hours,
an ox-heart, trussed with string
because its chambers
were stuffed with prunes.

Cut into finger-thick slices
and ringed with boiled mushrooms,
it served as a declaration of love
and was a tempting sight;
instead, rejected, it grew cold
on the plate across from me.

And this despite the fact
I had dusted the pitted plums
with grated nutmeg
and plenty of cinnamon;
ingredients that, since time immemorial,
have driven desire to ever greater heights . . .

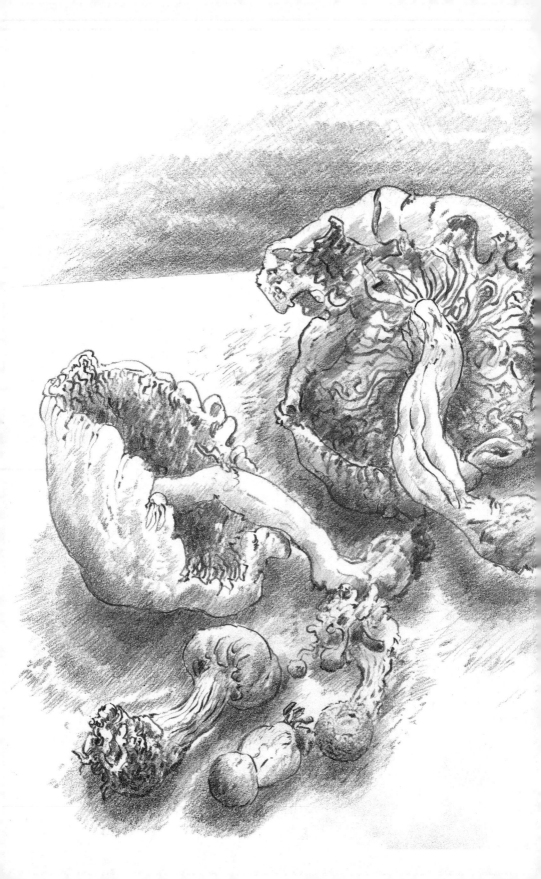

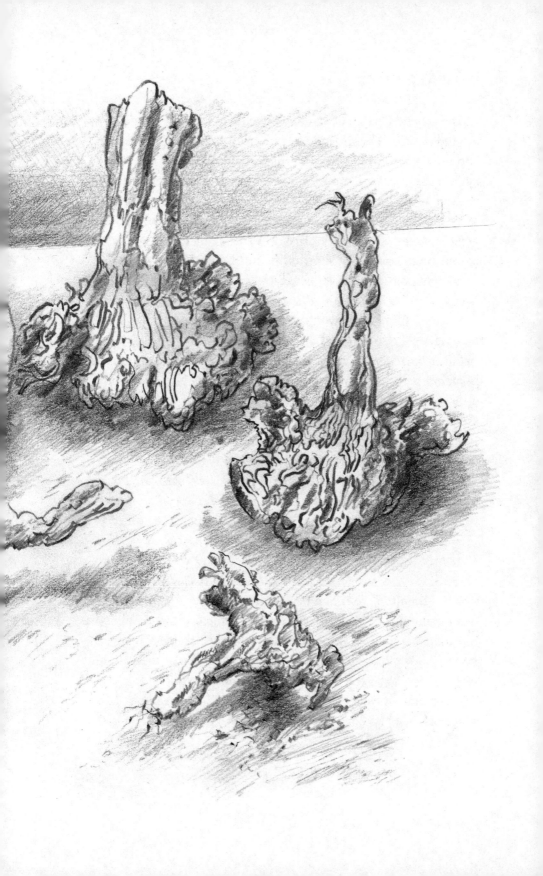

ON PAYMENTS

As the general decline of values was being universally decried around the clock by the man in the street, in lengthy essays, and on flat-screens and the Internet, arousing general assent and cynical commentary, money too went into a consumptive decline, though new currency was constantly being printed and circulated as a spur to speculative profit through virtual transactions on the global market. A race took place on a steeply inclined track, and the victor collapsed just short of the finish line.

Whereupon roundtable discussions both public and private were organized to pick apart fundamental questions: "Is money necessary?" Or: "What would life be like without money?" Or: "Is a moneyless age a threat or an opportunity?"

Silver-bearded anarchists long since relegated to the antiquarian book market were quoted. While autumn fell as Nature intended, abstruse ideas descended from the heavens with the leaves. Just as seashells had proved their value as currency in the early Stone Age, now acorns would pass from hand to hand, with beechnuts serving as change.

In late-night time slots the philosophers had their turn, taking radical positions and praising the monetary decline as a return to the essential. Even the newest pope, who chose to be called Francis, put in a long-awaited accusatory appearance in which he denied the apostolic blessing to avarice and the Church's own bank.

Since then the mountain of debt has grown as the Butter Mountain once did; on November days it pierced the cloud cover. Since then, a number of profit-addicted financial jugglers have fled to detox clinics. Since then, interest is a thing of the past, and was in any case, as the Bible tells us, the devil's work.

Nevertheless, we are starting to hope again, and ready to save diligently. We just don't know what to save, or why.

IN FRANKFURT AM MAIN

where Money lives,
Fear has moved in.
Thanks to tenant-protection laws
they can't throw her out,
nor her children, who are noisily playing
Black Friday outside the stock exchange.

make headlines, self-important, like sudden cloudbursts that soon trickle away. But I do recall: in a nearby village during a birthday party, when the name Elfriede came up in passing, rage splintered several chairs, and after a brief but bloody fight, the guests reseated themselves on the remaining chairs and chatted on as if nothing had happened.

A few days later, in the business section of a leading newspaper, readers were treated to a lengthy article on high-quality German goods; the same weapons manufacturers who led the war effort are still at work in peacetime, building tanks named for predators, and other high-quality armaments, to defend our liberal constitution in crisis-torn areas of distant lands.

And *The News in Review* lets us compare what occurred the very same day months ago in London and Aleppo — compare, for example, the number of gleaming gold, silver and bronze Olympic medals with the number of dead dragged off during lulls in the street fighting, laid out and covered with white sheets. That's how graphically events in various struggles pile up.

And then in the feuilleton: it seems our neighborhood fire department may have to close down. The usual economy measures. Nor have they found volunteers to put out careless fires or those deliberately set. But there's never any shortage of spectators to watch a neighbor's house blazing away.

PROPERTY

My God, your God, our . . .
So many claims of ownership.
And when the round of blather ends
just empty bottles
and steeples pointing upward.

WHAT BIRD WAS BROODING HERE?

Lost feathers waver
over the empty nest,
which stroke by stroke
I shape into a riddle.

fade in the archive, whisper, moan, sigh with desire, murmuring the old eternal litany. Celebrations too, threats, boring stuff simply marking time. And questions hungering for answers: Why? How? What for? No one remembers what it was all about. Guilt reckoned forward and backward, shoved back and forth.

Stamped letters, each bearing a date. A lengthy correspondence. A thief's fingerprint: private affairs now babble in public.

Lots of ordinary mail: acceptances, regrets, postponing something till later. A letter or two I shouldn't have written, others less abrupt, with no forced wit or wordy silence. This one I could still sign with all best wishes. And this one was never answered.

In the old days, mail was private. The mailman was one of the family; you waited for him. Conversations between the door and the doorjamb: How are the children, and the wife? The dog was glad when he arrived.

Nowadays there's seldom a letter among the junk mail, and almost never a handwritten one, one worth rereading.

Soon we will have nothing more to say to each other. No secrets between the lines or implied in a hand that trembles — unless mail arrives on its own, tenderly written in the sand at low tide.

LIBUŠE MY LOVE

Don't be so hard on yourself,
as if you'd been trapped
and sealed in amber.
Since you passed away
I've been following your trail,
traced only with lost words.

Recently I went looking for the castle
and found it in Bohemia.
You'd given orders
for diligent restorers
to renew its façades
on all sides.

They hadn't finished back then,
they're still at it today,
and they will be tomorrow.
Because it crumbles, cracks appear,
mold swells the plaster, withers its bright skin,
on the weather side first.

It comforts me, their toil,
for I too loved you
on all sides, in vain.

WHERE HIS HUMOR FLED

Having lost my way, as in a garden maze, in the Life of Quintus
Fixlein — or was it the jubilees of *Titan?* — I was shown the right
path by the helpful double star of Siebenkäs and *The Awkward
Age* — a path on which, I note in passing, a card catalogue of
never-ending wit waylaid me with tears of laughter — and arrived
at a Biedermeier-style literary circle where a gathering of demurely
coiffed maidens and overripe matrons were enjoying the flower
pieces of the Wunsiedel native, sharing the love they felt in com-
mon for the manic wordsmith; at which point I managed, with a
bold leap through time — a technique I'd copied from Giannozzo
the Balloonist — to escape into the present, where, in spite of
a flood of images and the constant noise, life seemed dry and
barren. Only serious matters, with no room for humor, seemed
to count. Everything had its price, or could be had cheaply at a
closeout sale, and the Introductory School of Aesthetics had been
shut down to save money; thrice barred, the door turned me
away.

The abundant spirit that flows from his books will soon be
remaindered. Who drove him out, along with his rich vocabulary?
I suspect his humor fled to lands created by his sinuous sentences,
fueled by excerpts gathered throughout his life, as nesting spots
for cuckoo eggs. I watch him as he watches himself hatch them.

IN THE ROLLWENZELEI INN

As he drinks his daily beer
swallow by swallow,
all the idolizing women—
except for the protective hostess—
having vanished into the blue,
Jean Paul looks over his own shoulder
as he writes,
writing as he does,
about how, as he writes,
he's looking over his own shoulder.

In that fat, bulging body
shivers a sensitive soul
thirsting for something
for which beer, swallow by swallow,
is a quickly vanishing substitute.

A LATE-NIGHT VISIT

The weariness that overcomes me by day, which I dismiss with a sneer or an ironic smile as a senile urge to flee back to bed, is actually a gift granted by old age, for the moment sleep turns its back on me, around three or four in the morning—when darkness darkens, to paraphrase Quirinus Kuhlmann—having tossed and turned till I'm thoroughly awake, I flee to my den, its walls shored up with books, and profit from the time, the time now running short, to scribble on blank paper or open the door to encounters of a special kind.

Just last night someone knocked at the door, a scholar of myth who was already ancient in his lifetime. He brought with him a gift of rolled tobacco from India. As we smoked, the conversation soon turned to *The Flounder*. Decades late, I offered him an apology: I was indebted to his masterpiece *The Raw and the Cooked* for its references to pre-Columbian notions of the origin of fire, and to the cunning theft that finally brought humankind the gift of soup, joints roasted on the spit, and warmer winters, but led as well to the invention of deadly weapons.

He smiled at my version of a tale he himself had discovered, in which a three-breasted Aua hides a small burning ember stolen from the divine Jaguar—an old wolf in my story—in her vulva, leaving behind a permanent scar that constantly itches; he smiled too at my great-grandmother's assault on the heavenly fire, over which she squats pissing until, hissing and fading, it goes out; and forgave me for having failed to name as my source of inspiration both him and those arduous field trips into the rainforests of the *tristes tropiques* where he lived with what native tribes remained.

It was no doubt politeness that led him to say how much my rewriting of the legends he had collected flattered him. The glowing ember in the vulva, he said, offered a vivid image of the transition from the raw to the cooked. He hoped I would go on creating variants. There were still many tales to tell. He knew other myths open to diverse interpretations.

When I replied that I was too old to do so, and felt unfit to work on anything in prose—except for a few scraps near the bottom of the barrel—the one-hundred-and-one-year-old scholar strongly disagreed. He took me sharply to task: Only the written word counts! And when I abruptly changed the subject and began discussing current problems in Franco-German relations, he just started murmuring in Indic languages. My late-night guest departed in silence.

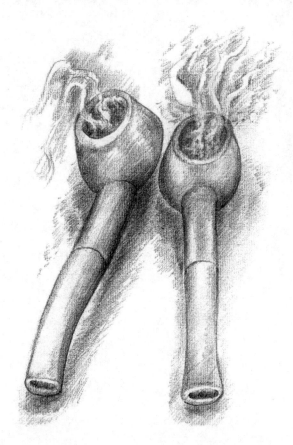

AFTER ENDLESS TORMENT

up and out of bed
to clear with a sharp pencil
the flickering void;
that's what we gain in old age:
sleep is a waste of time.

AND THEN CAME XAVER

Yesterday's storm had a name too, as others before it; as part of a series it would provide statistics, be of service to science, sum up total damage.

But this time—my notebook tells me—there was less destruction, although the storm surge on the coast was higher than in 'sixty-two, boosting the stock of companies that lend out guardian angels for a fee and insure all the small homeowners against the moods of an increasingly outraged Nature.

ACCORDING TO THE WEATHER REPORT

there are floods in the south,
while the north is drying out.
Tourists are fleeing here from there
and suing the climate for damages.

STILL LIFE

Atop the rotting windfall,
the storm recently tossed
the last apples and pears
and what remained of the leaves,
changing their color for my pen's pleasure,
and curling their edges.

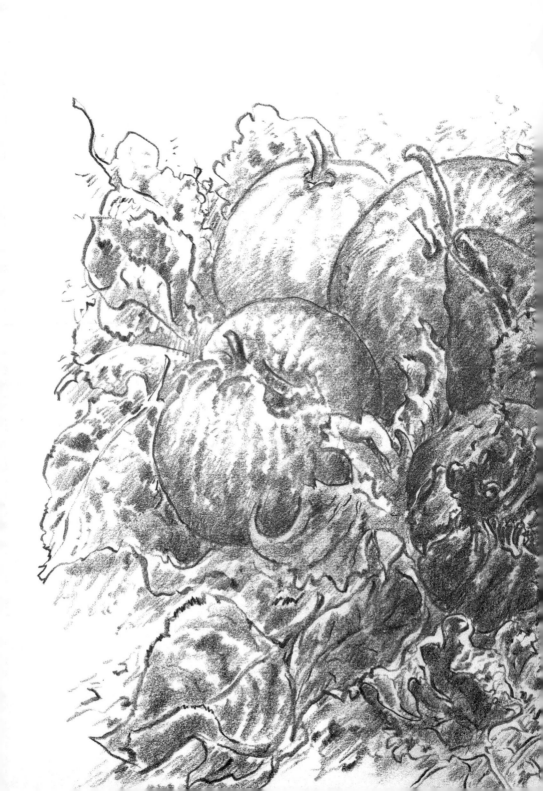

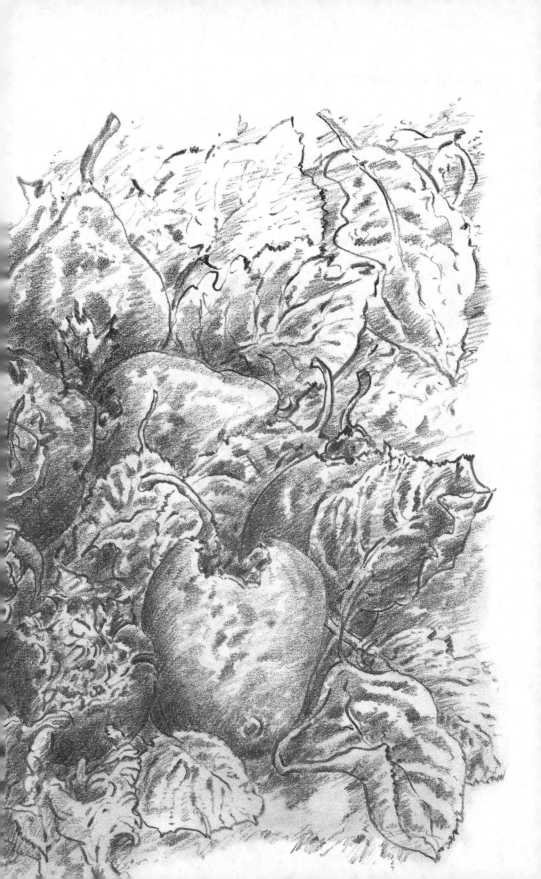

A LINGERING AFTERTASTE

Amid the winter-muffled crowd shoving their way along as if lost in a dream from stand to stand at the Lübeck Christmas Fair, among children pausing before sideshow displays of fairy tales filled with figurines, while my grandchildren and I were nibbling freshly roasted almonds, I was suddenly overcome by a feeling that had no apparent cause, unless sweets were suspect by nature.

It drained all sense and meaning from everything that claimed to exist, even the colossus of the cathedral thrusting into the dark sky. I nevertheless managed, with the shrewdness of old age, to disguise by false cheerfulness the weight that threatened to paralyze me; for half a century earlier, at the request of the city of Nuremberg, I had composed a speech entitled "Progress at a Standstill," which moved from past to present, focusing on Albrecht Dürer's copper engraving *Melancholia I* and the Coal Adjustment Act.

Ever since then I've known for certain that what is inadequately described as melancholy, and medically diagnosed as depression, forms part of my makeup. It affects humans and no doubt other animals. The gloom that accompanies it darkens things, but also grants insight, illuminates depths. Without it there would be no art. It's the quagmire in which I seek a foothold. It even provides an undercoat for humor. It holds an hourglass up to love, which sees only itself. The clock was invented to oblige it. Wherever progress claims to be making great strides, even with regard to what remains of Nature — or as today, in the midst of the Christmas Fair — it is present; melancholy overwhelms us for a time.

Even the childen — so it seemed — appeared slightly lost in the midst of their laughter, if only for one long moment. Then they were asking for things again, wanting things, this time a gingerbread heart.

ROASTED ALMONDS

From milk-teeth
to old age the smell
lures us from afar.
In paper cones
that keep them warm
in spite of winter's cold,
they gradually disappear,
but you can still taste them
when the pious scenes
of the Christmas Fair
have long been cleared.
Thus do old men turn to children
who never get enough.
They're always nibbling on something.

WHEN MY SENSE OF TASTE
AND SMELL DESERTED ME

Who pulled the rug out from under my feet? Who denied the Yes still inside me? I've visited various places for the last time. Cities, landscapes, friends far away. Nothing I pick up proves easy to handle these days. Empty drawers. It's time to practice my farewell.

Oh, go on! Those are just passing moods. So much that's new, still untasted, clambers over the horizon, cries out to be stared at, touched, used. It's all right to be amazed again. Every time our nose twitches, some new invention comes along to perform miracles we've only dreamed of. But now they are real; they create reality.

Why would anyone want to leave now? Why say farewell when everything that's ever been, is, or will be comes swimming into view through a new type of glasses? Now in a single instant we were, are, and will be. Welcome, not farewell, infuses all writing with light.

Think back, which should be easy enough. A few years ago, when your sense of taste and smell deserted you, when cheese no long tasted like cheese, pickles weren't sour, cherries weren't sweet, lilacs and elders bloomed in vain, and bread was cardboard, a god in immaculate white came to your aid with shots and round pills. And suddenly fish and sausages, radishes and carrots, all regained their own special taste, their own distinct smell, to which you'd been prepared to say farewell forever. Farewell to spring potatoes and pears in the fall. Farewell to dill, rosemary, and sage. Farewell to all odors, your own familiar fug, your own farts.

FAREWELL TO THE FLESH

I sing the woman's body, sing its praises,
slim to slender, in rounded fullness—
the likeness of a goddess carved in marble—
yet soon to be wrinkled, veined with blue,
as the seeking hand, still tender
and knowing, feels the bones, counts the little ones,
as if bidding farewell
to a skin once taut and smooth,
now dry and withered.

I sing of you, twin breasts,
who, when still young, fill fumbling hands,
when ripe are double pillows
on which to bed unease,
and when full, the kind sucking men
call tits, are well worn,
gleaming with sweat,
and licked by fear—
lumps might grow, cancer . . .

Slack, hanging bags—
Half full, half empty—
still recalling
how fully they once swelled,
I praise you all, all breasts
to which I clung: sucking, never sated,
exhausted, close to tears,
quiet, quiet at last;
or fallen into sadness
that knows only
the urge to be alone,
a man alone and sad.

Soon hoarse, I sing of you,
vulva, snatch, cunt,
snail in its shell,
my refuge since youth;
a spring now sealed.
Farewell to the firm ass
that out of the angled slope of the back
rounds its two cheeks
as if rising—the sun, the sun!

Farewell to hair, the thicket
I flounder in, caught.
Farewell to hands in constant search
of the undiscovered hollow,
the rest stop, the dew-covered moss,
the hole in the hedge.
That leaves the arms and legs,
those legs, those arms, wrapped around me
for thousands of years.

Farewell to the open mouth,
that welcoming cave, the play of tongues
that knows no rules, sufficient unto itself.
Farewell to the slow plunge,
the primal sound, when suddenly
what's left of the animal
awakens with a groan, whimpers,
till the cry—dully, then swelling,
driven to its peak—the cry
rises and rises . . .

Farewell to flesh that lies hidden,
wrapped in wool, velvet, taffeta,
in rough linen.
Too many buttons, a zipper that's stuck,
cloth over cloth in flowers and stripes,
and beneath it all, silk—black or white—
till at last the body
lies peeled and naked,
still closed, womanly,
yet barely touched,
becomes the breathing flesh I sing,
I praise since Adam, and we are as one,
as it is written.

All my life, still felt in dreams,
love charm and manna.
Flesh from which I was born,
born hungry for more;
no, no pinup,
no airbrushed flesh
rosily promising everyone
it will last forever.

In Nature's given form,
as sung, as praised by me,
body surrounded forever by whispers of love,
to which, when still, my pen
gives outline,
follows its rounded curves,
forms hills and — past all horizons —
levels and smooths out all.
Casting shadows,
revealing landscapes
constantly new, chastely empty,
each one different.

A farewell that finds no end,
a song that never dies —
Ah, my dear, most dearly loved! —
into what shell, what ear,
murmured on the beach.
Verse upon verse,
receding softly, advancing strongly,
then monotone and nearly still,
till far from all flesh
the body turns to stone.

STACKED LUMBER

On a Sunday family excursion through the Oliva Forest, heading
for Freudental and an inn where long tables awaited us with soft
drinks, coffee, and *streuselkuchen,* I see the compact figure of my
paternal grandfather, a self-employed carpenter, as he pauses sud-
denly and stands in thought before a tall smooth-barked tree.

His gaze travels up and down the trunk. Nodding apprecia-
tively, he sounds the bark. More to himself than to his patient
family, he estimates how many meters of lumber the beech will
yield.

Signs point the way. Slowy the family moves on. We can't pos-
sibly get lost. Grandfather pauses once again, takes measurements.
A cuckoo may have called.

After the war, during which his workshop turned from making
furniture to outfitting barracks, he sat on his packed suitcase as a
deportee. He sat facing east, a displaced person believing firmly in
Chancellor Adenauer's promise: he would be going home soon.

He was sure down to the last detail: the carpentry shop would
be waiting for him, the supply of door and window frames he'd
left behind, the friendly tools, the circular saws and bandsaws, the
transformer and the planer, the lumber stacked under tarpaper in
the woodshed.

My grandfather kept hoping till the day he died in Lüneberg.

XENOPHOBIA

As millions of displaced persons
with little luggage,
burdened by memory,
were forcibly resettled
in what remained of the fatherland,
many of the locals, feeling cramped
by their arrival, shouted:
Go back where you came from!
But they stayed, as did
the well-worn cry: Go, get out!
Soon it was aimed at foreigners
who came later, and later still,
from far away,
speaking in strange tongues;
they too remained,
settled down, and multiplied.
Only when the natives
began to feel foreign too
did they also begin to see,
in all those foreigners
who'd slowly learned
to bear their foreignness,
their own selves,
and start to live with them.

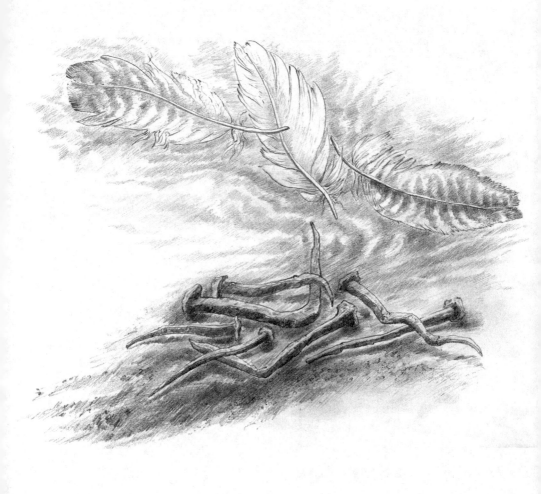

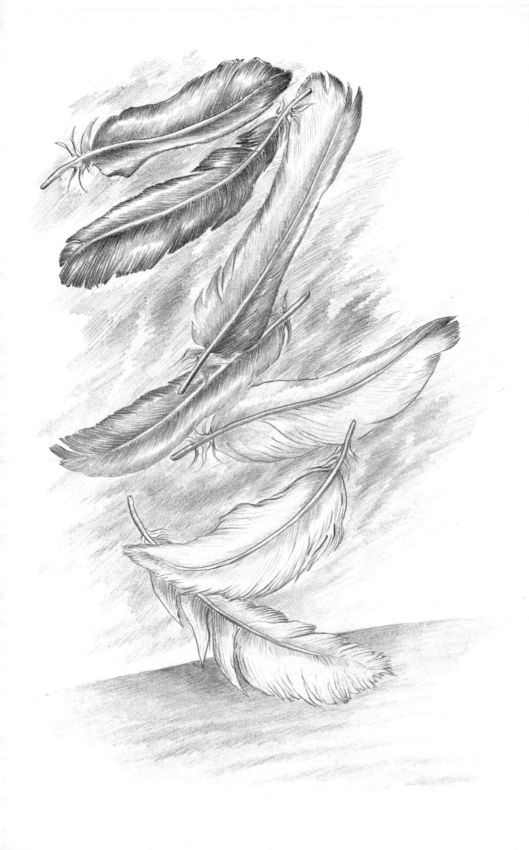

HOW AND WHERE WE WILL
BE LAID TO REST

At long last, having discussed our joint project many times, testing and rejecting various ideas at the kitchen table, we had reached a decision; the master carpenter Ernst Adomait sat across from us. The conversation began over tea and cakes, hesitantly at first, but soon underway.

Adomait has worked for us for years. He's built standing desks and bookcases, and various smaller items for my wife. We told him what we wanted, never defining it as our last will and testament. After looking through the French window into the summery, windless garden, he agreed to take the job and make the boxes. He suggested they be measured separately for length and width, and we agreed. He had no objection to our request for two different woods: pine for my wife, birch for me. The boxes would be of equal depth, but hers would be two meters ten long and mine two meters. My box would be five centimeters wider, to match my shoulders.

When I said "not tapered toward the foot," which was once standard and may still be customary, he nodded in agreement. I mentioned Wild West films in the course of which this sort of plain carpentry grew in demand. My sketch on a paper napkin proved unnecessary; the idea was clear enough. The boxes would be finished by autumn. We assured him we were in no hurry, but laced the conversation with hints about our combined age.

The style of the handles was still under discussion. I wanted something in wood. My wife favored strong linen straps. In any case, there would be four on each side, to match the number of our children. How the boxes would be sealed was left open for the time being. The conversation was down-to-earth at first, and dealt with practical details, but soon turned almost cheerful. When I suggested setting the lids loosely on top—"after all, the weight

of the earth will hold them in place" — or fastening them down with carpenter's glue, Adomait permitted himself a quickly fading smile, then declared pine and birch dowels more suitable.

"A costly method," he warned. Alternatively, screws could be inserted in carefully-drilled holes. I favored hammering in old-fashioned nails with solemnly resounding blows at a given signal. In the postwar years, I often put up gravestones in cemeteries while working as a stonemason, and once made a deal with a gravedigger: five Lucky Strikes for a good dozen hand-forged coffin nails; later, much later, they appeared as rusty assemblages in drawings, lying this way and that, a few crooked, each with its own shape. And every nail had a tale to tell from its past. Sometimes I added dead beetles lying on their backs, and bones large and small. In one drawing, nails and rope hinted at a death only humans could devise. Soft pencil, hard-line pen and ink drawings, all of them still lifes, a few found buyers intrigued by their cryptic nature.

Adomait seemed to follow my digressions more out of politeness than interest. Then we chatted about current affairs: the ludicrous rise in the price of petrol, the uncertain summer weather, the now-familiar bankruptcies. I set a bottle of mirabelle plum brandy beside the empty teapot and what remained of the cakes. "Just a small glass," said the master carpenter, who still had to drive home in his truck.

By the time Adomait left, we'd decided on wooden dowels and rough linen handles on each side of the boxes. "We can count on him," my wife said. "He has always delivered on time." The interior decoration of the boxes hadn't come up that afternoon, since it didn't involve carpentry. The only thing we were sure of was that padded upholstery, cotton or down, was out of the question. That sort of expense might be customary in commercial coffins, but we weren't looking for comfort.

It was only at breakfast, after my usual complaint that my mat-

tress was too hard, and when the dishes had been removed and the tabletop was bare, that an idea came to me, somewhat vaguely at first, but soon assuming a clearer shape. I suggested that after the obligatory washing of our lifeless bodies, we be laid to rest on a bed of leaves, then covered with more leaves by our daughters and sons, using whatever Nature offered, according to the season. In spring, budding leaves would cover us; in summer, fruit trees — cherry, apple, pears, and plums — could lend their lush green, mature abundance. Autumn, my preferred season, would make its brightly colored offering. And dry, rustling leaves could deck our naked bodies in winter. The old walnut tree, the copper beech, the maple, would provide variety. A handful of walnuts could adorn our leafy cover as an extra feature. Only the two chestnut trees outside our house, sickly for years, would be forbidden to add their rust-afflicted foliage. I also requested there be no oak leaves.

At any rate, when the time comes we will rest from head to toe on leaves and be decked with leaves. At most our faces will be free, perhaps with rose petals on our closed eyes, a custom I witnessed during our stay in Calcutta: there I saw some young men trotting along, carrying the body of an old woman on a bamboo pallet to a cremation site on a tributary of the Ganges. Bright green leaves were pasted over her eyes.

In addition, my wife chose not to forgo a shroud — one she said she would sew herself.

That seemed preparation enough. Over the course of a time no longer ours, all would decay, the box and its contents. Only bones large and small, the ribs, and the skull might remain, unlike the bodies buried in the bog in Schleswig-Holstein, now placed on show under glass in the Schloss Gottorf Museum. Those bones turned soft; you could still see tissue, skin and knotted hair, as well as bits of clothing, relics of a ghastly prehistoric age, of scientific value, eagerly sought as fodder for bog-bodies stories, like the

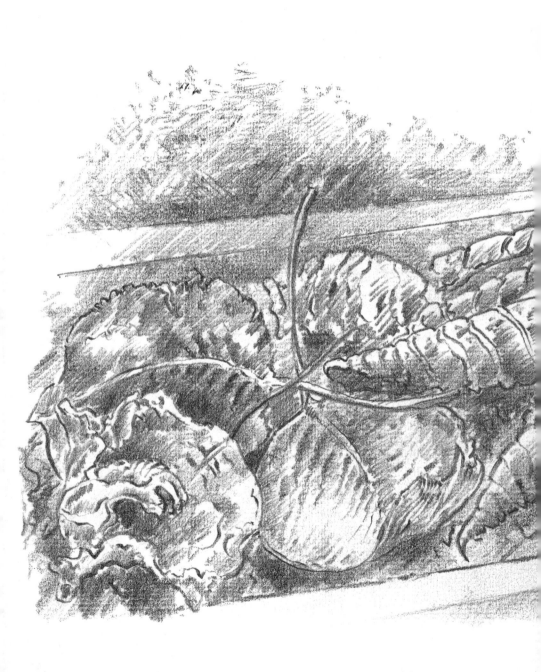

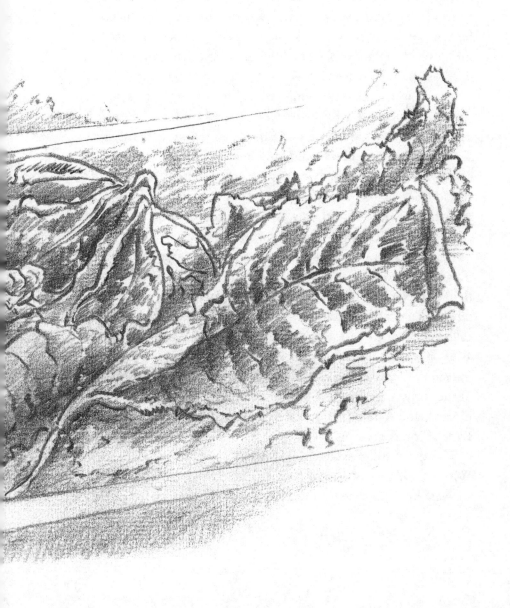

one of a young girl whose face was covered with a strip of cloth in punishment for some atrocity that could scarcely be imagined.

The skull, on the other hand, has always harbored a rich store of meanings, from the ingenious to the ludicrous. Piled high or fitted into walls, skulls rest in the vaults of monasteries. A skull adorns the pirate's flag, serves as the logo of a soccer club. It signals a warning on cans of poisonous, explosive or flammable material and appears as a motif in the fine arts, in oil paintings and copper engravings like the one by Albrecht Dürer showing Saint Jerome in his study. Withdrawn from all worldly concerns, he bends over his books, while the fleshless skull beside them reminds us of the transience of all living things, that from birth on, death is a settled matter.

But we weren't that far along yet, in spite of our increasing frailty. The planks for the boxes we'd ordered could be cut to size, but a few questions were still in the air that were harder to answer: What carpenter would build a refuge for the wandering soul, whose existence we both desired and doubted? What façade would reach high enough for the climbing ivy of immortality? How might we be reborn, as worm, mushroom, or resistant bacteria? What other beings might inhabit the void?

In addition to ivy, we could spend a rampant afterlife as weeds no gardener could control. And what of creatures that creep and fly? With Nature's all-powerful help, I've always hoped to be reborn as a cuckoo, drawn to the nests of strangers. Promises were called out year by year. Even leaving God and his own assurances aside, speculations remain that won't fit in our boxes. Only the transitory nature of their contents can be guaranteed: the rigidity of the corpse, the greenish-blue discoloration of the skin, gassy, bloated, and soon bursting, the onset of mold and all the other signs of rot, the worms.

Things we still need to think about — the final question: Where should we be laid to rest? A good thirty years ago, when we were living in the city and first thought of looking for a plot,

I favored the cemetery in Friedenau. But my wife had something against Berlin as our final station. In the end I did too, since soon after the Wall fell, the city's claim to be the nation's capital gave rise to too many shiny bubbles of loudmouthed boasting.

Having moved many times, we considered various cemeteries —with Lübeck as a cozy backdrop—but reached no decision. One near the railway station, where you could sense rows of graves behind the boxwood trees, would have matched my endless longing to travel. But since we wished to be at rest, a double grave in our garden, between the studio window of my workshop and the shed, with nothing but the woods beyond, would have been our preference. But in spite of our country's solemn canonization of private property, burial on one's own land is forbidden by law. Cremation remained the only way out, followed by a fake theft of the urns by our sons, so our ashes could eke out their shadowy existence behind the blackberry hedge or in the lilac bushes.

But having no wish to deny the worms our mortal remains, we decided against ashes and agreed to talk with the pastor of Behlendorf about making the local village cemetery our final address. A meeting was easily arranged. The pastor, who turned out to be quite affable, if somewhat overburdened by the spiritual welfare of his current souls, understood our aversion to resting among the rows of graves, since as individuals and newcomers we were unfamiliar with the neighborly or familial entanglements of the villagers at rest there. Even our tactful suggestion that as hea-thens we would feel out of place near the medieval outer wall of the chancel was, if not warmly received, at least quietly accepted.

We finally settled on a tall, solitary tree off to one side. Beneath its spreading branches I paced out a rectangle the size of a quadru-ple plot. The pastor told us that this was in an area bordering the cemetery, once a pastoral potato field, unused for some time now, lying fallow, so to speak, although at present it gleamed invitingly as a meadow.

During a pause in the conversation we pictured ourselves lying

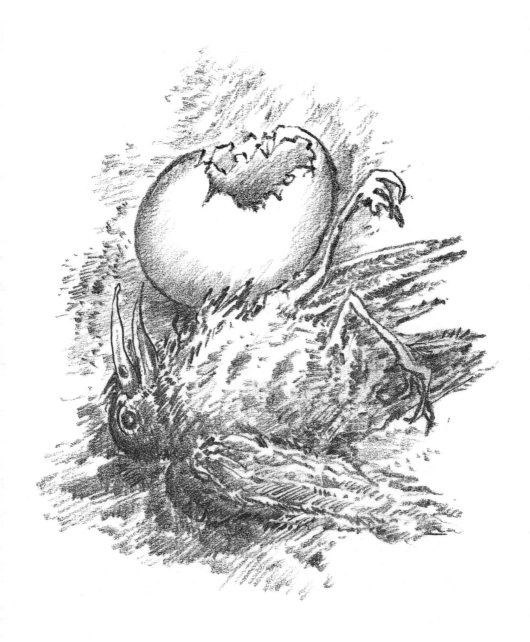

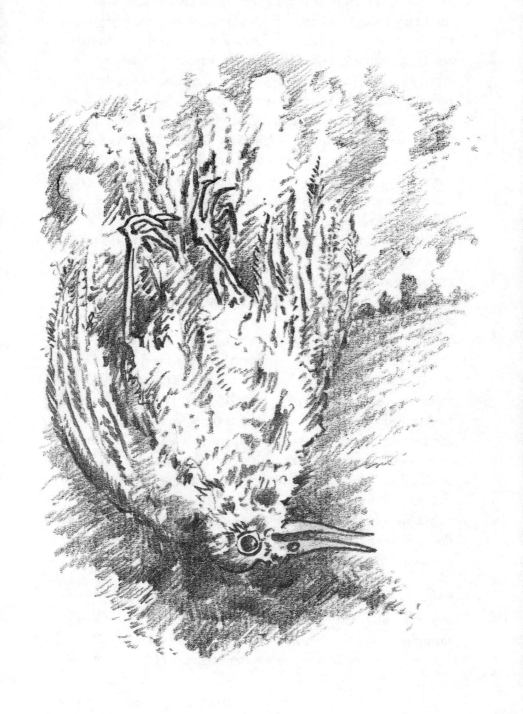

there, or as the survivor visiting the first to go. As decorative shrubbery I suggested herbs: majoram, sage, thyme, parsley, anything used in the kitchen. On the eastern edge of the measured quadrangle, an erratic boulder, borrowed from the local end moraine, would serve as a gravestone. The stonemason would have the job of carving our names and dates in cuneiform letters. "No other inscripton or quotation, please." The boulder would have a broad base that asserted its weight without being overpowering.

I paced out the approximate size of the plot again, this time farther from the root system of the tree. Getting the church council's approval for what we wanted, the pastor assured us, would pose no difficulties.

When we got back home, we were a little tired. I treated myself to a coachman's glass of calvados. On the kitchen radio the evening news reported various crises competing for the limelight. According to the weather forecast, rain would continue in the south only. We didn't tell our dog about our successful search for a resting place.

One Saturday in mid-September, after the second pacemaker they'd implanted declined to give my heart the help it needed, and my lungs began to repay me for decades of self-indulgence in hand-rolled cigarettes and well-stuffed pipes, we were relieved to see the carpenter arrive with the boxes. Ready to use. The look of them, the bright wood, each with its own grain, put us in a good mood. Even Adomait, a serious man on principle, seemed satisfied, and confirmed his mood by attempting a smile.

We had cleared a temporary space for the boxes in the back of the cellar where we kept our garden tools and deck chairs. Plastic covers would protect the boxes from flyspecks and mouse droppings.

Seeing them side by side like that reminded me of a special term for coffins from the old East German days: *Erdmöbel,* earth furniture.

The eight handles stood at precisely measured intervals. Al-

though well seasoned, the wood smelled new. Without lids the interiors beckoned invitingly.

Before leaving, Adomait did not rule out my now customary offer of a shot of plum brandy in celebration. On top of the bill, which was more than reasonable, he placed a clear bag of wooden dowels for the lids; he had drilled matching holes in the upper rims of the boxes. There were several extra dowels in the sack. As the carpenter had suggested, my wife stored them carefully in a drawer of her desk where, along with the usual odds and ends, she kept our passports, the dog's vaccination certificate, and other important papers.

The very next Sunday, with no visitors scheduled, we removed the protective covers, as well as the lids lying loosely on top, took off our shoes, and lay down in the boxes. They were the right length and shoulder width. We made no comment, so solemn was the anticipation of our laying out.

How strange to hear each other breathing. My wife helped me climb back out. When we had replaced the lids on the boxes, we spread the covers over our final homes and gave free rein to our thoughts, which remained, however, unspoken. Shortly afterward, my wife said she was sorry she hadn't taken a picture of me in the box; she would be sure to have her camera with her next time. "You looked so content," she said.

Once we'd had our trial lie-in, as we called our visit to the cellar, life went on as usual. While my wife was preparing supper —two perch with jacketed potatoes—I sat in front of the tube watching the usual Sunday-evening world news with its images from around the globe. When I saw the two fish lying side by side in the pan, with cucumber salad on the side, the comparison seemed so apt I couldn't help joking about it.

The boxes have been waiting ever since. From time to time we remind ourselves how beautiful they are. I'm too shy to ask my wife if she's finished sewing her shroud. But I know we'll have plenty of leaves to clothe and cover us. They will always be avail-

able: newly fresh in spring, lush green in summer, brightly colored from October on, faded and brittle through the winter.

So let another year or two pass. We're not in any hurry. At the moment my pacemaker is doing its job, as promised. Even the children and grandchildren, when they come by for a brief visit and bring up the deck chairs from the cellar on sunny days, have grown used to the sight of our master carpenter's custom work.

Lately my wife has started storing dahlia tubers and other flower bulbs in her box for the winter. Next March—we hope—we will plant them in the flowerbeds and cover them with fertilized soil from the garden.

TO PASS THE TIME

Reread books you finished long ago,
deliver indignant diatribes,
redate history, this time in reverse,
restore words you once crossed out,
plant young trees where the storm
felled the old,
see butterflies with closed eyes,
patiently count dead flies
fallen from the windowpanes,
chew memory like gum
that still has a little flavor left,
pass time with guessing games
and twiddling thumbs,
visit that spot in the cemetery
and now and then lie to the clock.

As a child by the fringe of the waves
on the Baltic rich with beaches,
I built high-towered castles
out of dripping sand:
barely finished, lapped on all sides
and dried by the wind, they quickly fell.
Each castle quickly fell.

THAT'S BY ME?

They were done over sixty years ago, when I'd found a place to stay in the Caritas Home in Düsseldorf and began my apprenticeship as a stonecutter and mason, then later as a student at the Art Academy: more than two hundred works, drawings and watercolors on cheap paper.

Later I lived on Stockumer Kirchstraße. Horst Geldmacher —known as Flute—and I set up an atelier in the rear courtyard, in the attic of a stable that could be reached from the outside by metal stairs.

And under those stairs, between bulk rubbish and worn-out mattresses, Ekkart Peliccioni, who took over my room, found a packet I'd forgotten all about in my haste to leave Düsseldorf, almost in flight, early in January of 'fifty-three.

In mid-July this past year, he and his wife stood beside me as I untied the string that bound their aged gift. Musty old paper. Frayed edges, dog-eared, mouse-eaten, stained, brittle. The drawings seemed so unfamiliar. "These are by me?" Drawing after drawing revealed gaps in my memory. The watercolors—apparently done during and after my trip to France—reflected a new and changing scene. The ink drawings were done with a more self-assured and mannered hand. Closer to my heart were the portraits of old men from the Caritas Home, who modeled for me under the trees; I paid them two cigarettes per session.

Amazed, I rattled around in my memory, trying to find the young man in his early twenties in the studios of Professors Mages and Pankok. A few things took shape. Many cast no shadow. What was drawn before the currency reform and what after? I see Franz Witte juggling colors. Jazz jumps shrilly from Geldmacher's flute. Jupp Beuys in Jesus sandals. What was the name of the porter at the Academy? I bribed him with postage stamps—a complete set of the Free City of Danzig—when I needed an easel, model stand, and turntable for the atelier on Stockumer. Who were the women who posed as models, slim or full-figured, while I drew nudes? Who was driven by such single-minded diligence?

Who was I back then? What did I want to be or become? Who and what was left behind when I mounted the interzonal train to Berlin with my meager luggage — the midwife's case stuffed with tools?

I left a city that, by clearing away the ruins, the image of war, had rid itself of memory as well. Now money and the newly rich were everywhere. I was terrified by the so-called miracle. Brightly polished bull's-eye panes, top-fermented beer, Rhenish cheerfulness, the Altstadt and its pubs, where artists were part of the decor and pretended this was Paris on the Rhine. Impressed by the applause of satisfied beer bellies, some drank the night away.

Left behind was a bundle of used sketch paper, perhaps a few poems given to young women, and friends who later got caught in the city's gears: Horst Geldmacher, who was forever smashing his flute, and Franz Witte, a genius going to waste . . .

FAREWELL TO FRANZ WITTE

Where did you go?
Leaping nimbly through the window
of the mental institution,
as I see you still, leaping
from car top to car top:
a blurred figure impossible to catch,
always off to somewhere else.

Your paintings held great promise.
What might you have become?
Perhaps an El Greco, reborn.
More likely — I fear — the gigolo
in a pleasingly fake bohemia.
I should have taken you with me, my friend,
when I made my getaway.

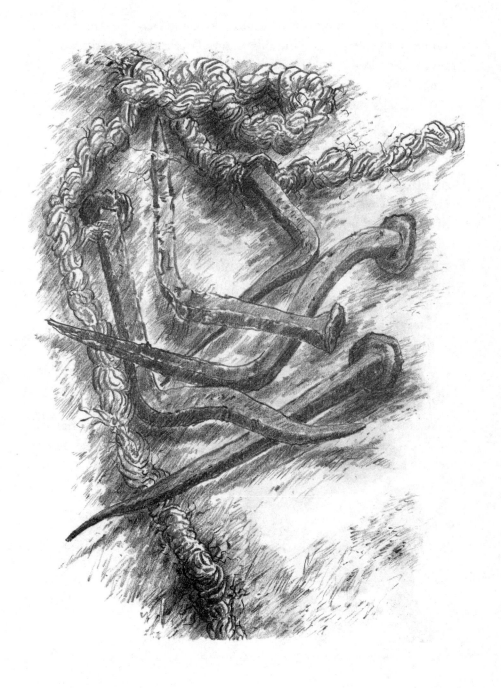

LIGHT AT THE END OF THE TUNNEL

Today a newspaper equally committed to capitalism and cultural values carries a report on the situation in Greece. Fewer and fewer people can afford to heat their homes. No work and no pay has sapped their spirit, and cut off their gas as well.

So Greeks young and old have been sitting in freezing darkness since early winter, unable to heat their soup. Driven by necessity, they start open fires in their rooms or try to warm themselves with candles that give off some light; from Athens to Salonika, on islands large and small, homes are going up in flames. Sirens are heard everywhere, often arriving too late. There are reports of deaths.

Yet turning for advice to the paper I'm reading I learn that, with all due sympathy for the country's situation, a positive lesson may be drawn: the economic restrictions imposed on the all-too-lavish Greeks are working. Moreover, the first signs of economic recovery are evident; the long-awaited gleam of light can be seen at the end of the tunnel.

The admonishing voices from Europe—not least the stern words of our chancellor—have been heard and followed, though still not in sufficient measure.

So anyone in the birthplace of democracy who owns a belt, this widely read newspaper suggests, had better pull it tighter, cinch it in notch by notch.

MUTTI

A mildew the rain can't wash away
coats everything that happens now,
everything that brands the landscape.
Habit incapacitates us,
while consumption everywhere rises.
We grow and shrink at the same time,
good citizens turned good consumers
forking over whatever it costs, driven by desire,
market-oriented democrats
giving in willingly to a woman
who glares at us one day
and smiles kindly the next,
sugarcoating the pill that makes us meek as lambs.

What might disturb us is eloquently silenced;
she says nothing in so many words.
Anyone who gets too close is snapped at,
then fed to the media for breakfast.
She's surrounded by special interests
sworn to lie in wait for profit,
who, like the Mafia, put the screws to her.
To "Mutti"—mommy, as we call her in jest—
we are a flock of children
who sometimes go astray.
But she has diligent lackeys on hand
to restore order without spilling blood,
pledged to keep us safe and quiet as we sleep.

She'll deal with anyone till he's milked dry
and dangling limply on the clothes hanger.
Even the socialists have crawled into bed with her,
paid off with crusts of charity.
A majority coalition, near megalomania,
reflects its power with foolish pride.
Soon we'll be hearing, as if in passing,
the abdicated Kaiser's immortal words,
slightly softened in Mutti's own style:
We're not quite there yet,
but—used sparingly—we might be
marketed, not as pepper, but as
the salt of the earth.

HOMESICKNESS

We're not descended from apes. We're extraterrestrial in origin and strangers here, for millions of years and more ago an overpopulated planet had to lighten its load. The old had no wish to die; new generations grew rampant. So it came to pass that airships similar to legendary UFOs flew over a largely overgrown region of green that later, much later, we called Africa. Rich in wildlife, it appeared impenetrable. Barely landed, the ships unloaded their cargo: surplus individuals of both sexes, as well as convicts and bands of teenagers, all more or less resembling us.

At first they made a civilized impression; even the convicts behaved in an orderly fashion, shaved, combed their hair. Their belongings, stowed in shipping crates, were equally sensible: tins of food, mineral water, toothbrushes, toilet paper, makeup kits, battery-driven vehicles and all sorts of technical odds and ends, with their knowledge stored on chips. But deadly weapons were part of their equipment too.

It wasn't long before they felt the effects of the climate. Supplies ran out. Medicines proved useless. Gear rotted. Their knowledge was not enough. And since their home planet sent no one after them, starvation reduced their numbers. Exposed to an alien environment, few survived. Those who remained were forced to adapt; they turned wild, stopped shaving, no longer bothered to brush their teeth. Shaggy-haired, they forgot where they came from, their nameless planet. Legends were their only reminder.

Time passed unmeasured. As our remaining ancestors increased in number, they split into tribes, drifting from place to place, became hunters and gatherers. They battled each other with hand axes, clubs, and later, much later, sharp metal spears.

This history we know, down to our day. Only when we search for planets light-years away may we see, amid a shimmering galaxy, one that was once our home. Spurred on by homesickness, we send spaceships into the universe—in search, in costly search. Ah, if we had only stayed home, we wouldn't have to believe in Darwin and his fairy tales about the apes, in the deeply rooted, irradicable once upon a time . . .

WHEN, AS REQUIRED BY LAW

millions of tomcats and stray dogs
were castrated, first here, then everywhere,
the razor-sharp thought occurred,
with an eye to mankind,
that in light of overpopulation,
similar cuts might be necessary;
soon it will be law, first here, then elsewhere.

THESE ARE FACTS

The butterfly's question "Is life just a dream?" has been transformed into a popular form that eats facts, then digests and excretes them as fiction. We are told that our egos exist only in cyberspace; everything that lives and communicates is digital; anything outside the Internet just feigns existence. We are immortal only if we are registered and stored as data.

So street fighting in Aleppo and Homs merely feeds data banks; the bombs exploding daily in Iraq and the dead laid out under sheets are fake corpses, copied from computer games, which are real; Gaza is just a hoax, ridiculed by millions of users, just one more shitstorm.

In order to speak at all, such common doubts must be swept aside. For if I say, in the somewhat questionable guise of a real person, that once the so-called German army has withdrawn from a far distant land, thousands of Afghanis who aided our returning soldiers will be left exposed to the hate and revenge of the Taliban because we deny them asylum, I am stating facts for which we bear responsiblity, even if those facts have already been turned into easily digested fodder for the giants bred in Silicon Valley.

In spite of this, some friends and I wrote an appeal entitled "Emergency Call" in nonfading ink on paper that actually rustled. Yet a nationally distributed newspaper refused to publish it: "We don't publish appeals!"

BEFORE IT'S TOO LATE

Let no one say, as too often in the past,
we didn't know.

Not one among the silent righteous
will be spotless.

No one can spend the week in silence
and be absolved on Sunday.

We must never again build memorials
to victims we treated thoughtlessly.

No one will look in the mirror
without reflecting guilt.

The shame in flowerpots
is rooted in the past.

COVERED LOSSES

We had two or more thieves in our house recently—in our cellar to be precise, which has an outside entrance.

They managed to break in unnoticed, though we were sitting in front of the TV that night watching an old crime movie—set in Paris of course—about a jewelry robbery, in suspense-filled black and white.

Nothing was missing from the cellar but the two long boxes we had built, one of birch, the other of pine.

We asked ourselves: What will the thieves use them for? As there was no snow on the ground, they left no tracks.

Since then the winter months have trundled along with only moderate frost. The loss troubles us. The two dozen dahlia bulbs my wife was storing in the box built for her are also missing. They were waiting, like us, for the coming spring. Of course we're insured against theft, but only the losses in wood are covered.

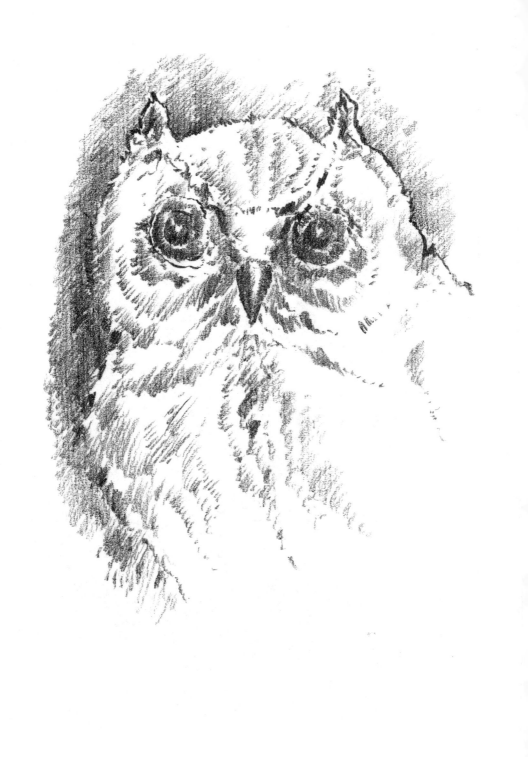

A WINTER TOO MILD

How sparse the woods are.
Bare-branched they await the snow
now falling elsewhere, on palm-trees
says the weather report.

THE OWL'S STARE

Beyond the scurrying mouse
and the curled worm
its stare reflects us,
visiting the zoo on Sunday,
looking for answers.

ABOUT CLOUDS

our Hans Magnus has written the most beautiful poems. They change as you watch, which pleases him. He loves how they bow first to one wind, then another. They're not for sale. Their shapes constantly shift. The sunset's makeup tinges them but briefly.

In my youth, dominated by Baltic weather I always remember as "clear to cloudy," though our schoolboy holidays were often overcast and gloomy, I liked to spend time "pushing clouds," as my son Franz did much later on. That was our phrase for making mischief, a job that paid by the piece. Things changed of course, but I was always dependent on the mood and goodwill of the weather.

Ah, how dull the cloudless sky that spreads over us today.

RISING TO HEAVENLY HEIGHTS

Clotted on the horizon
they rise to the mountains
or, in loosely gathered mounds,
are wind-driven east to west.
Silvery white,
framed in gray.
Plucked cotton
—plucked by whom?—
arranged in rows.

Who was the boy
lying on his back in the sand,
trying to direct
the traffic in that
wash-blue sky?

Tiepolo too, rising to heavenly heights,
lay on his back on the scaffold,
painting his celestial visions.
Behold, you who are weighed
down by leaden soles,
how his heavenly host,
enraptured, have found
among the clouds
a softly cushioned home.

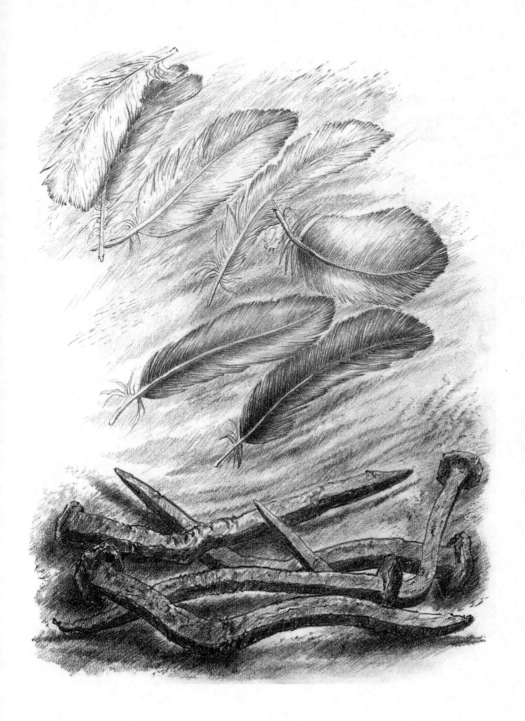

ON WRITING

I started setting down words early on. At first in Sütterlin script, its long loops with me still. A diary was lost in the war, near Weißwasser, during the retreat. Then came the peace, which had to be absorbed. Hunger helped, chewed up everything, including books. And when I fell for art and love at the same time, an Olivetti arrived as a wedding present. She was and is my favorite product from the fifties, sleek and elegant in form, as if Leonardo da Vinci had invented the typewriter on the side.

I've remained true to her. I took her on trips with me. The drafts I wrote by hand she ate like fodder. Her clatter was music to me. I often hit the wrong key. I still do, even if I'm not writing now, but just trying to go on.

Over time, many things have disappeared. Long-playing records and cast-iron skillets for example. Her ink ribbons were in short supply too, given her insatiable appetite for what I rolled in and out; ribbons turned scarce, threatened to disappear entirely, so that even used, they brought a high price at flea markets.

The first computers were on the market and seemed sure to dominate the future. Then something wonderful happened, not here, but in Spain: a small group of students who had read in magazines about the old-fashioned way I wrote book after book sent me a foil-wrapped package of brand-new ribbons, and though their number decreases year by year, they should see me through to the end.

GRANDPA'S BELOVED

I have to sit out the rest.
One orphaned standing desk
is simply storage space now,
the Olivetti cries for attention on the other,
except when my half-grown grandchildren,
here on a visit, stare in awe
at my playmate from a time
when windfowl were still around.

She's still beautiful
and—always ready—wants
a fresh ribbon, of which
seven remain.
But she's new to the children,
invented just yesterday.
They put in a sheet of paper
and type with one finger: clack clack.

I read: This was once Grandpa's beloved.
He even took her on holidays.
Sometimes he strokes her.
He had a lot of children with her;
they grew up long ago.
Now she's sad because,
he tells her with a wink,
he can think of nothing more to say.

Once I dreamed my wife and I were in a concert hall. I saw us
in the front row, then again farther back. At a lighted podium, a
tenor was singing to piano accompaniment. No, he was a bari-
tone. I'm not sure if his vocal cords were trained on *Dichterliebe*
or the *Winterreise.* My wife, if she weren't dreaming too, could
recall it more accurately, for where music was concerned she set
the tone for our love from the start.

After the concert, with nothing noted or of note having hap-
pened during the intermission, the dream swept us into a recep-
tion, apparently in honor of the celebrated singer. Guests were
standing around, relaxing and discussing local affairs rather than
the songs we'd just heard. I stood there with an empty glass feel-
ing left out. Suddenly I noticed my wife was gone, and I searched
for her in vain. Queries drew only shrugs. I started to think I'd
wandered into the wrong dream when I turned and saw her slim
figure poised beside the equally slim singer. They were engaged
in conversation, or rather, the conversation engaged them, held
them captive. In beautiful harmony, with no wish to be disturbed,
they stood in mutual admiration.

Nevertheless, I approached the couple now conversing so in-
tensely. Enthusiasm inflamed them, an inner fire, the devil knows
what it was.

My dreaming ear took in the nuances of the performance that
had just faded away. For example, whether the pianist, who would
be either fired or never hired again, had played too loudly or, in
certain passages, too softly.

Their heads were drawing near, too near. Their voices died out
breathlessly. Their fingers spoke silently. I saw myself shunted
aside, tried to dream up something different, a rugged landscape
with a waterfall. But when my wife approached me, after a mov-
ie-like cut, I was hardly surprised to hear the clear and emphatic
statement that she was leaving at once and moving to Leipzig

with the singer — that's right, not to the German Democratic Republic of dreams but to the real one; it was her desire and privilege to accompany the singer on the piano from now on.

I quickly gathered what little wits I had about me, struggled to free myself from a numbing jealousy, availed myself of an inward logic countering that of the dream, and heard myself say: I'm coming with you to Leipzig.

She accepted it. Just like that. A small smile, characteristic of my wife in real life, announced agreement.

Then the dream grew more complicated. My request for permission to leave at once for the other Germany led me to various departments where I was forced to undergo interrogation-like interviews. The decor of the rooms smacked of offices in East Berlin.

In the end, I had to assure them in writing that I would make no public appearances on socialist soil and, moreover, would refrain entirely from writing. Rapidly and without hesitation, moved by a love beyond doubt, I signed various papers. Seals were affixed with a bang. I renounced everything with dream-like ease; as the song says, I kept my eyes on the prize.

From then on, we formed a ménage à trois, one in which bed scenes were off-limits. I saw myself cooking for the two of them: no doubt a bland diet. And wonder of wonders, after a short time, insofar as time can be measured in a dream, I could read music. My enjoyment of music had always been passive, but now I heard harmonies when I looked at the page. Ah, if only I could have retained that gift when awake!

Wolfgang, called Wolfie by my wife, was a singer whose fame knew no bounds. As a result, he was allowed to travel abroad on tours that brought in hard currency. In my dream I traveled with this exportable duo as their page-turner. So I continued to be of use, expertly and as inconspicuously as possible turning the pages

from time to time when such immortal numbers as *Winterreise* and *Dichterliebe* graced the program. I was an essential part of the whole.

We took the stage in Paris, Milan, Edinburgh, even in Sidney and Tokyo. The world seemed a beautiful dream. I also enjoyed a small advantage that was a constant source of pleasure: Wolfgang, or Wolfie, was so worried about his voice that he avoided all drafts, any sudden changes in the weather, and the smog of great cities. When not rehearsing or performing, he spent all his time in temperature-controlled hotel rooms, where our wife pampered his vocal cords with herbal tea and an inhaler. All this left me free to visit museums, cathedrals, Buddhist temples, and other places of interest. The glimpse into the gloomy dungeons of the Tower of London was unforgettable. Something I never dreamed of: a stroll through the White Nights of Saint Petersburg, called Leningrad back then.

I would leave straight after the concert, while the two of them rushed back to our hotel room. They never saw the midnight sun, saw nothing, experienced nothing but the changing concert audiences, applause.

So we lived in harmony as long as the dream lasted. It might have turned into yet another novel, perhaps one too many. But since the end of the real GDR wasn't on the program, the question of whether our ménage à trois would have survived the fall of the Wall remains open.

WHEN THE MONSTER'S EYES TURN GREEN

a clenched word occupies
bed, table and chairs,
therapists earn too much doing too little,
exotic fare from other tables
leads us to question what he
or she has that we don't,
reason sulks, shoved to one side,
dreams are suspect from the start,
green dominates all colors,
knuckles rap on property thought ours,
rage bursts through open doors,
a tie or shawl smells
of forbidden flesh,
films give cues,
hormones go wild,
mirrors go blind,
milk curdles in coffee,
one hand is tempted to open
letters held in the other,
oaths are demanded by the dozen,
toothache afflicts the soul,
hate grabs sharp objects,
glass shatters, longing screams,
and the stock of love,
stored in jars in a cool cellar, threatens
to dwindle, spoonful by spoonful to dwindle.

FEAR OF LOSS

You might before me. Or those friends who remain. The list keeps getting longer. Or someone, a spy, working for whom?, empties secret drawers: abysses dear to me. Lost and not found. Suddenly it's missing, the key, and I'm forced to wander outside, freezing, although the sun, as if to mock me . . .

Other things threaten to vanish: names, addresses. Memories of a woodland path, heading where? Something I was pleased to discover: the petrified snail has crawled off without a trace. Funny and painful at the same time: I'm traveling with a full pipe, but no match. Or put another way: virility, that swaggerer, has gone limp. Only desire remains and acts as if. Now if desire too were to disappear, leaving just a hole...

And if one day, when tears have long dried up, perhaps in May, I can no longer laugh? And lose all the fingers on my left hand. Or the right. What would I do?

Not long ago I was searching, as I so often do, for my eraser. Hopeless. The mongrel Fear attacked: with my last tooth I might lose other things too, the boulder I rolled, and you, who make up for my more recent losses.

GONE GONE GONE

Recently I opened a wardrobe
locked since ash-gray times.

Coat hangers dangled inside,
holding nothing.

Hanger after hanger I weighted
with the clothes of dead friends.

To make sure they lasted,
I put mothballs in all the pockets.

One hanger stayed empty,
for me I suppose.

Then I locked the wardrobe
and swallowed the key.

IN THE GREENHOUSE

for poetic seedlings many gardeners toil. Some sow their seeds in crumbling walls and blistered asphalt, to sprout as flowery sprays or stinging nettles. Others deal with exotic plants, intoxicating fragrances. Many sip honey from paper flowers. And some steal flowers from the beds of others.

I wait. A burned-out bulb may give wondrous light. Or the coin that rolls down the groove may trigger a long-impending collapse. A missing word may be snapped up in passing, fit into lines of verse lying in wait. And footsore opportunities that slow everyone down: nothing falls from the heavens like dew.

From the beginning, rules were begging to be broken as they tripped smoothly along, so syllable-counters ran wild. But now an age-old plant whose multicolored fruits were used for alliteration, inner-, cross-, and end rhymes, is about to hit the market genetically modified.

The effort it took yesterday to pair "computer" with "Martin Luther," "Internet" with "corset," or "clone" with "drone" will soon be a thing of the past. By tomorrow, glib robots will provide all the odes and elegies we need to put us in a poetic mood. We can each tend our own little plants in the greenhouse.

But since we already have too many poems, the experts crowd the best of them into anthologies. When Peter Rühmkorf, a high-wire artist of poetry, died around noon one summer day, his wife pulled out Conrady's big book of poetry and shoved the thick tome under his chin to hold his mouth closed.

But—left behind—I just can't stop, and since the calendar says March, and decades ago the beginning of spring went to my head the same way, I'll write another poem about the month, because—as I say—I just can't stop . . .

MARCH AGAIN

The rose named Shakespeare,
planted by love's own hand
to the right of my workshop door,
urges the rising sap
to put forth shoots.

She wants to show me how it's done,
to prick me, morning after morning,
to express myself, as she does,
even if moved only by fears
that promise panic blossoms.

Once I praised March
with words honed to wedges
driven into every knothole.
Everything lay open; only the angels
were too tight and dry.

UNTEACHABLE

When I was six and a half, in nineteen thirty-four, having barely started school, I was taught not to use my left hand. The slate pencil scrawled slowly across the matte-gray board.

Since then I have written with my right hand, but I'm more sensitive with the hand I use to hit, throw and hold a knife, and when, stooped by age, I walk along the canal—the dog ahead as always—I take my walking stick in my left hand. In all else too, unteachable, I stand far to the left, even of myself.

THE END

After recently steering a sentence
around three corners,
I found by leafing back in time
that I had already written
this three-corner sentence
with more precision in two corners.
That's the end, I shouted,
but this cry too lay
on paper faded years ago.

MY BOULDER

When, like other young men and women in the Düsseldorf Art Academy, a cigarette clung to my lower lip as a badge of existentialism, bobbing up and down at every word, it was Albert Camus who rolled the boulder of Sisyphus our way—in German translation—just after the war. We whetted our tongues on it. It gave the naysayers a chance to say yes. And to know: the moment the boulder reaches its apparent goal, it rolls back down again. There's no stopping it.

Yet it longs to roll back up the mountain. That is its will, and my will submits. True, I haven't grown fond of it, yet it's mine and keeps me from placing too much hope in those who make great promises. I may praise it or revere it, I may scorn it, call it a punishment or a gift. It sets me apart from the new aristocracy of cynical conversationalists for whom no boulder is worth the effort. It's not overpowering; no, it's rounded, you can roll it, though it's not easy. It speaks invitingly of human dimensions, gives courage. To try to escape is pointless; its call draws me in.

Even in sleep I lay my hand on it, help with my shoulder. I sweat for it. Pride cajoles me into saying it makes me strong. Sartre, its adversary, peevishly tried to deny one of its aspects—the semblance of happiness.

But now I can do no more. Panting, I sometimes sit on the boulder, sometimes lean against it. Will someone come to relieve me? Someone strong enough to move it? It's starting to gather moss. The mountaintop is covered in clouds. I still dream of boulders, smaller ones now, pleasing to the hand.

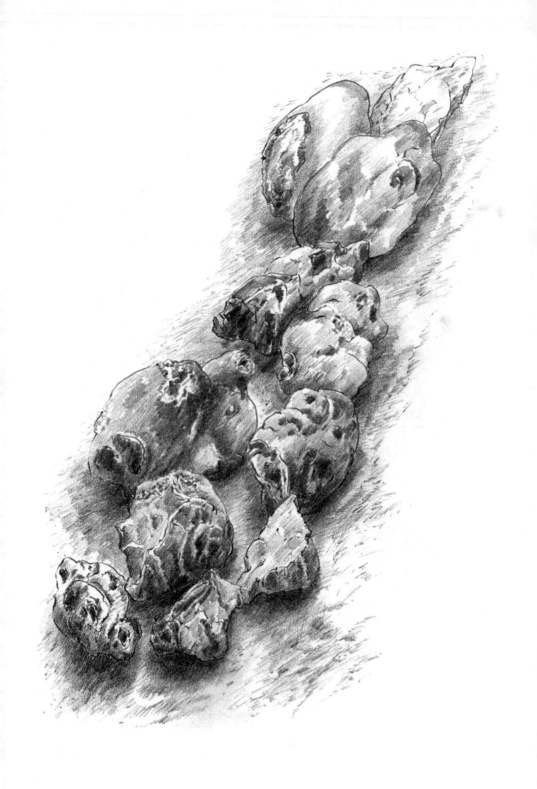

WHAT THE BEACHCOMBER FINDS

Flintstones, rolled by the sea's fringe,
flecked black and white like the cows
grazing in the nearby field,
bluish-gray, smoothed between ice age and ice age.
Each rounded differently,
long hidden in chalk.

Now they swell my pockets.
Whistling, I carry them home.
Now they lie on the windowsill
in conversation with feathers,
which — not so light as they thought —
fell from the sky.

Stones and feathers share jokes,
primal humor that never ages,
deriding gods in suits and ties;
whoever hears them laughs too soon,
or years afterward, when it's too late,
too late again.

LAST HOPE

A cruise ship left Genoa recently and traveled on as usual to seas both north and south, then entered unknown waters. At the passengers' request, it anchored in the bay of a green-hilled island the tourists named Utopia.

And it came to pass that a submarine left over from the last war, or the one before that, still on the lookout for prey, though its crew had grown senile, spotted the hull of the ship named *Hope* lying at anchor and, at the word "Now!," sank it with a torpedo saved for just such an occasion.

As they say: all it takes is the right word and an act of will to find the imagined enemy in
the crosshairs.

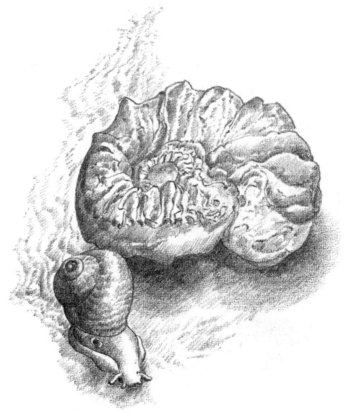

NOW

is over and gone.
Now longs for permanence,
dances on a thin wire,
and cries as it falls: see,
I'm still here.

Now is urged on from behind
by a runner who has no goal
yet whose pedometer
measures time, counts each step,
and each step says: now now now.

No nail can hold it,
scarcely here before it leaves,
it comes and goes in an instant,
unless He swings his scythe
and ends Now's fleeting being.

Death alone is always there,
the single syllable that waits
on call is his alone,
it breaks off long sentences,
cuts short the sleeper's dream.

What remains is backdated trash
and frayed adhesive tape
with holes through which the future blinks,
knowing nothing better to say
than now: now now now.

SO THEY CAN CONVERSE

The soft pencil suggests
that beside the bare elk skull—
a dusty birthday present—
I lay my dentures
to make a five-line poem.

NAIL AND ROPE

chat about artfully-tied knots;
the nail laughs itself crooked
at all the slips that occur,
but the rope
is plagued by dreams of being tested.

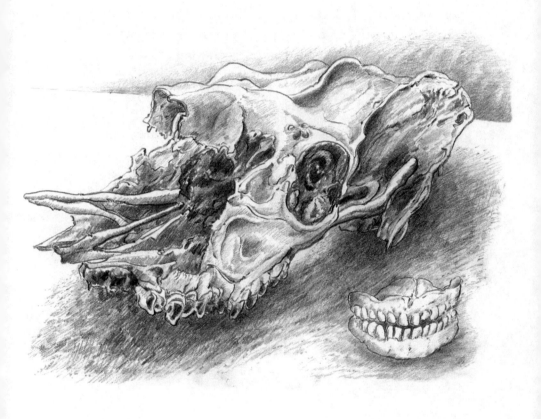

SUGGESTION FOR A SOUVENIR

Calcutta still captivates me. In front of a shop selling mini-cigarettes called bidis, along with betel nuts and fresh white coconut, I saw a bundle hanging, its braided tip a glowing ember used by smokers passing by; my pipe caught at once.

I couldn't tell what the bundle was made of: sisal perhaps, or hemp.

Later, much later, I asked my friend, the artist Shuva, to send me one. It's been lying untouched in my workshop ever since; I've never used its braided tip as a permanently glowing ember.

A chorus of doctors convinced me that smoking is lethal — though Death, busy elsewhere, is taking his time — so now my pipes lie scattered about, cold and ill tempered.

I still hesitate to give them away; they cry out to be drawn in soft pencil beside the sisal-hemp bundle, with its useless rust-brown beauty.

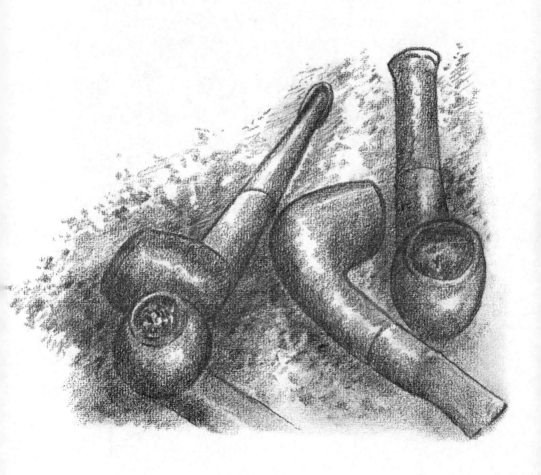

TWISTING A ROPE

From loops of gut and leitmotifs,
from spidery-soft twined lies,
from straw plaited with the wind—
glued sugar-sweet—
from a bundle of rust-brown sisal hemp
a friend once sent me
by freighter from Calcutta,
glowing at its braided tip
as a permanent lighter
for the pipe I used to smoke
from dawn to dusk,
I'll twist a rope—
since my pipe lies cold—
weave wisdom tightly,
till a hundred knots and more
have been entwined as riddles.
Who can or will or wants to solve them?

PAINTING PORTRAITS

In the far reaches of the East, where distances are measured in versts, not miles, artists whose names, except for two or three, were lost along the way, wandered from cloister to cloister, painting the Madonna and Child on old wooden panels. Just her and the tiny child. Not that they couldn't have painted other subjects — say, men with long beards — but endless requests made them rest content with this one pious motif. They were specialists.

As a rule their Madonnas stared straight on. A few were allowed a slight tilt of the head. They resembled one another despite their varied formats. The panels were hung to catch the eye in onion-domed churches or took center stage on home altars, with candles on either side. Wrapped in prayer, pilgrims whispered their requests, some of which — wonder of wonders — were fulfilled.

Later, experts spotted differences among the various Madonnas, identified schools of art, and arranged collections in chronological order. A few portraits glistened with gold leaf. Icons were always a favorite target for thieves, looted in times of war and carried off to distant lands where they now hang in museums. Some may have been forged.

When art no longer strove to be timeless, but wished instead to evolve, there were artists who painted icons in the contemporary style, mostly without Child. One of them came from far in the East; his name was Jawlensky. He is famous to this day. His icons are sometimes sold at auction. Often I bid along, but I'm outbid every time, if not by the Japanese, then by nouveau riche Russians with room in their vaults.

STARED RIGHT THROUGH ME

Recently a dream led me
to the Greifswald museum.

There was much to see, fishermen with boats,
solemn men and women, vast landscapes.

But it wasn't Pomeranian art,
nor Caspar David Friedrich, that drew me.

It was a narrow room
into which I was led.

In it hung a dozen or more paintings
lined up in a row.

They all showed polychrome heads
of great beauty.

When I told the museum guard
that I too owned an icon from this series,

he stared right through me
at a gap between the sightless heads.

His reply, "A Jawlensky was recently
stolen from us," still troubles my dreams.

ON THE FIRST SUNDAY

in May one of my grandsons was confirmed in the village church. After family breakfast at a long table, we set out on what was for me a rather strenuous climb up the hill to the church tower, the pointing finger. Chestnut trees and elders were showing off outside; inside most of the pews were full. The bells rang to hurry the latecomers along.

After a sudden silence the pastor, who had been busying himself between the altar and the congregation, surprised me with his strong voice and rhetorical skills. Rakishly he filled his double role as entertainer and shepherd of souls. Two instructions — "Be who you are!" and "Do something!" — were the pillars of his sermon, which oscillated between song and prayer. He drove home to the dozen or so young boys and girls that they were grown up now. The confirmands stood with their backs to us and received the pastor's words patiently. Now and then the congregation had to stand, but were soon allowed to sit again. The pastor never sat.

It was all very entertaining. The ceremony, which lasted almost two hours, struck me as a variant of the old East German *Jugendweihe,* where teenagers were given adult status under socialism, especially the pastor's galvanizing call, "Be who you are!" and "Do something!," which, however, he put in God's mouth. To one side of the altar, hockeysticks, balls of various sizes, and helmets illustrated youthful pastimes. Strangely enough, a gingerbread heart was among them.

Then came the blessing of the dozen or so present, who displayed their multifarious hairstyles. Every now and then we sang from texts before us. As I sang along, my thoughts were lost in the past. Though I'd been inoculated in the Catholic faith, I could not recall the moment when I knelt in the Langfuhr Herz-Jesu-Kirche. I must have been ten or eleven years old. In any case it was before the war, when Danzig was still a Free City, for I saw the image of my grandfather's communion gift, a silver five-

gulden piece. And yes, I could see myself in short pants kneeling at the grille in the confession box, but what I couldn't recall was just when my childhood faith began to melt like a scoop of vanilla ice cream.

Oh yes: halfway through the evangelical *Jugendweihe* the organist played an Adagio and Andante by Torelli, accompanied by a cello. That was as beautiful as the weather outside.

ON THE BACK PEW

I like to sit in empty churches,
although my faith, quite early on,
as my pimples were first surfacing,
did a disappearing act.
But contending with the Holy Ghost—
attempting to refute
the old dovekeeper
with tales of rats—
is something I still enjoy.

SUPERSTITION

I've always counted along, even if it's not rational. How happy I was whenever he kept on. At times two called together, back and forth or in duet. Those didn't count, or were meant for someone else. On my way to the heath, I would stop the moment he called and shut my eyes.

Just a game that tells how many years you have left. I've only seen him in pictures. He's considered nondescript. And laying eggs in someone else's nest isn't restricted to birds. Perhaps he taught humans to count. Once—I don't remember when—I reached twenty-seven.

But when I stepped out the door today, the sun suddenly broke through the clouds, and the Great Promiser set my allotted time. Joy and shock. Now he calls again. But I don't believe him.

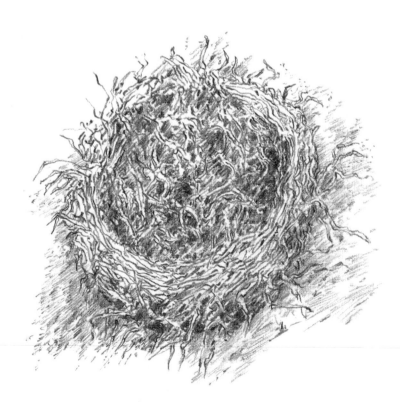

HE CALLED THREE TIMES

The cuckoo, of course. Who else?
His fourth call broke off in the middle,
rattled away, died out.
So little time left:
three and a half years?
Ah, so what, that long at least . . .
Too little and too much.
Yet the next time I tested it,
I was barely out the door into the open air—
me with my doubt and my belief—
when he stopped again at three
and that gift of a half.
I'm making plans.
I'll plant a sapling,
beech or cherry or plum.
I'll risk a trip,
don't know where yet,
sharpen my pencils, more than three,
and blow on feathers
as I've done since I was a boy.

DEAR SCHNURRE

Once, when you, the shadow photographer, were still with us, you told me a story from your rich store as a gift for later use.

It was about a childless couple who lived in a house near the Italian border. I don't remember what the village was called. One day their car was gone, stolen. Not that unusual a loss, you might say.

But a few days later their Fiat was back in the garage, without a dent or scratch, and washed clean. A letter lay on the driver's seat beside the car keys; it was from the thief, thanking the couple for the emergency "loan" and inviting them to La Scala in Milan; enclosed were two tickets for a Verdi opera, *La Traviata* no doubt.

Pleased, the couple set out on the trip, but when they returned home shortly after midnight, still enraptured by the powerful strains of the music, they found their house empty, stripped bare.

I write to you, dear Schnurre, because after a theft further back in time, something similar happened to us, though with a different gift.

STOLEN GOODS

They're back again,
both boxes,
oblong and inviting.
Stolen last winter, they stood
undamaged in the cellar,
covered in blue tarp,
one summer day
when we returned from a trip to Poland.
Only the dahlia bulbs were missing,
having bloomed elsewhere, perhaps.

What moved the thieves,
at no small effort, to return
our nearly forgotten boxes —
one made of pine,
the other of birch —
to the place from which they came?

No letter or note explained their return,
but lying in my box, side by side,
cushioned in tissue paper,
were two dead mice
of delicate beauty: their finely outlined
empty skulls, their dainty rib cages.

We puzzle over it still.

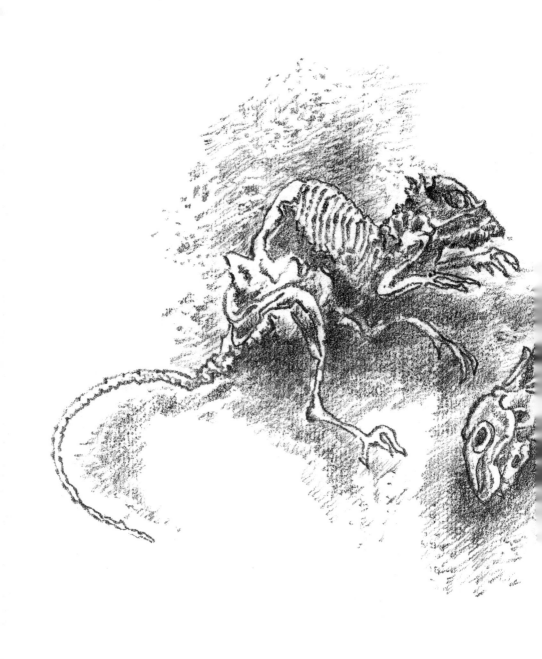

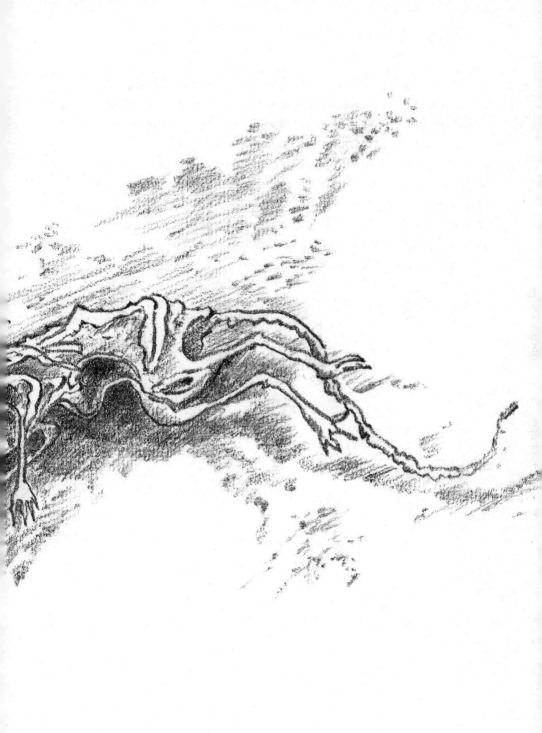

FOUND OBJECTS

at rest, then rolling when struck. The sorts of thing sold cheaply at flea markets. I've always fingered objects my eye fell on, silent under questioning till I conned them with one of my stories.

No finder's fee. Early on, heading for school, I came upon a curly-bearded key for which I sought the lock all my life.

Heirlooms passed down over time, bomb fragments and jagged bits of every shape. Something casts a shadow. Something useful that was lost. Something lying unnoticed in the dust. A plum-size piece of amber that brought me joy, in its innermost chamber a Darwinian insect that disproved God.

On trips I watched at the city's edge as children poked about in the trash, finding things, tossing them back. And I saw myself among them, till the many-fingered horde drove the stranger off.

IN WHAT'S LEFT OF THE ALTSTADT

Since big-jawed excavators
laid bare the traces of a medieval sewer,
construction projects
considered urgent
have been halted by order
of the city's Office of Historic Monuments.
They hope to find undigested bits of food.
What filled stomachs in the past
will be compared in value with current
nutritionally balanced meals.

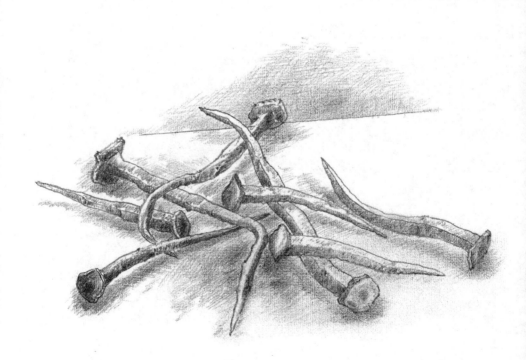

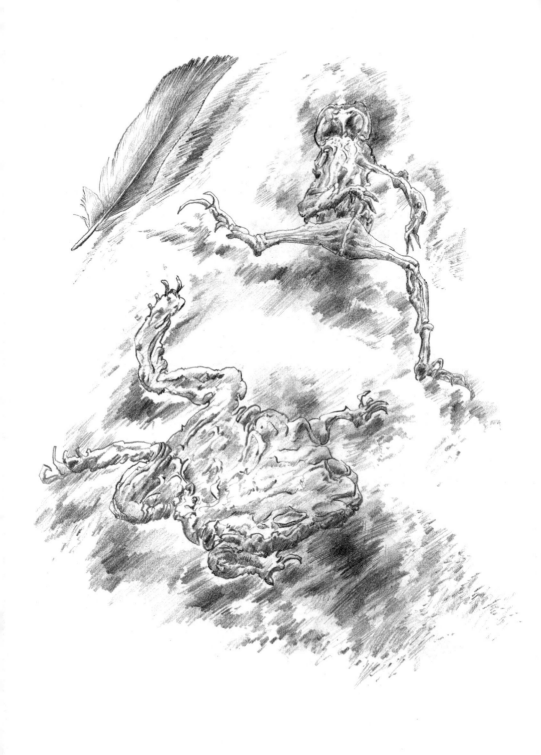

DANCES OF DEATH

What drives me, summer after summer, to collect toads and frogs
dried to scarred leather?

After the final ecstasy they lie on the sandy path to the heath,
squashed flat.

I keep them in a basket, filled on good days with plundered
brown-capped mushrooms.

Later, strung out in a row, the dancers form a circle.

Quickly, before the music ends, my pencil renders them
immortal.

STARED RIGHT THROUGH

by the cow behind the fence,
I whistle the dog back.
Barking for no reason.
Nothing troubles her gaze.

TRACING TRACKS

Beside the waves' fringe
I meet myself—coming and going—
barefoot in the sand.

HUNTING SEASON

Picasso's bird of peace has changed into a clay pigeon. Traps spit them to the heavens. Hit after hit. Anyone can take a shot—even with a pointed finger. Woe to those caught in the crosshairs. Facebookers make lists of who's to be shot. Not a fashion show runway that doesn't boast the latest outfit: bulletproof vests. They wear them to school in America, as they soon will here.

OPEN SEASON

They fire their shotguns,
filling the air with lead.
Early on I learned to find the gaps,
avoid the scattered shot,
though now and then I lost some feathers.

SUMMING THINGS UP

Gone, gone, gone! Like all the others, broken off above the root. Lying among odds and ends, near the mosquito sealed in amber and last year's tattered peacock feather, yet clearly on its own, a solitaire on the shelf above the standing desk, bare now and barely used.

No more toothaches. I can finally say "finally." I still know a few stories: the short one about a dog that bites its own tail, and the longer one where the milk turns sour. And I think of some so funny you'd die laughing, like a Nobel Peace Prize for the arms maker KraussMaffei. But someone else will have to tell that one, someone with a bite.

More words wear out. People keep dying before their time. Reality comes secondhand. I'm on the sidelines. Running short of matches. I'm slow to say Now.

Someone who means well tells me to sum things up before my hand starts to tremble.

BALANCING THE BOOKS

in a row, pressed close together,
name and titles on their spines,
my identity card, still valid,
though long since expired, well thumbed.

I no longer know which of my selves
filled page after page with words,
nor scarcely sense where the drive came from
to capture solid, hand-held objects
in sentences short and long.

I only know I had to write
the words that stood there
in white chalk on a blackboard,
telling me what to say, whom to defy, why,
told to what end.

Books in a row, side by side.
A wooden shelf, walls left and right,
supporting them through time
in case there are readers yet to come.

They ceased to be mine long ago,
and yet they're still a heavy burden.
That's the sum total. Is something missing
that could add to the bottom line?

AUGUST

The leaves grow weary. Spiders hang swollen in the web. Wars are breaking out. In the kitchen Inforadio reports rapidly developing fronts. An epidemic spreading. Body counts. Slight volatility in the market. Scotland just wants to be Scotland.

The hundredth birthday of the First World War draws near. The age-old question of guilt is posed again. As Walther once did, I sit on a stone and prop up my chin.

IN THIS SUMMER FILLED WITH HATE

With drought here, rain-swollen floods there,
shocked by the destruction of sacred art,
we thought of the First—as the Third
broke out in several places—as simply
a rehearsal, practice for the real thing.

As always in August,
the moment the fields are shorn bare,
the harvest brought in,
the daily labor paid,
I sat motionless in shadow
on a stone.

My left hand holding my head,
my arm propped on my knee—
thus I sat,
sat and sat
and held my breath
in this summer filled with hate.

HERR KURBJUHN'S QUESTION

Each morning on my way to work, just short of the house beyond the dike where my studio awaited, Herr Kurbjuhn stood among the sunflowers behind his garden fence, gave me a smile that broadened his furrowed face, and said in Kashubian, "Well, my friend, what's new in politics?" My reply went on too long.

The village we lived in at the time, like all villages between the North Sea and the Baltic, took in large numbers of refugees from East Prussia and Pomerania at the end of the war — a presence you couldn't help hearing. Some of the older ones enjoyed telling stories from the past. They talked just like Herr Kurbjuhn, but he was the only one who called me "my friend," till the day he no longer stood among the sunflowers.

They were called displaced persons. A language died with them that has warmed me since childhood, and whose remnants I've tried in vain to save. I remember only Herr Kurbjuhn's question: "What's new in politics?" But not my answers on those mornings at the garden fence.

OF ALL THAT ENDS

All finished now.
Had enough now.
Done and dusted now.
Nothing stirring now.
Not even a fart now.
No more trouble now,
and all will soon be well
and nothing remain
and all be at an end.

ALSO BY GÜNTER GRASS